SHELTER DOGS
IN A PHOTO BOOTH

GUINNEVERE SHUSTER

Andrews McMeel Publishing®

a division of Andrews McMeel Universal

INTRODUCTION

My passion for shelter and rescue dogs started at sixteen, when I picked up a stray dog on my way to work. I ended up adopting the year-old, silver-coated Australian shepherd mix after no one claimed her from the local animal control. I named her Dandelion, my heart dog and soul mate for five years. Dandelion saw me into adulthood before the playful pup was diagnosed with osteosarcoma, bone cancer. A leg amputation was followed by failed chemo treatment, and five months later we spent Dandelion's last week on the Oregon coast with our toes dug deep in the sand watching the moonlit waves.

I have worked and volunteered with all sorts of animals from dogs to horses to giant African millipedes and even emus. I studied photography, digital imaging, and the fine arts in college. As a junior in college I was encouraged by a fellow student to volunteer my time photographing homeless pets at the local humane society. I quickly fell in love with photographing shelter animals and my weekly volunteering efforts turned into a full-time career.

To date, I have photographed over 6,000 shelter animals. I hope that photographing shelter animals in a unique and positive light will not only result in their adoption but also will encourage those who have never considered adopting a pet to check out their local shelter or rescue.

Guinnevere Shuster, December 2015

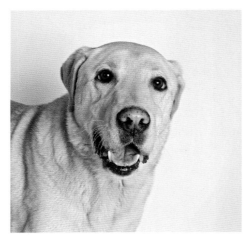
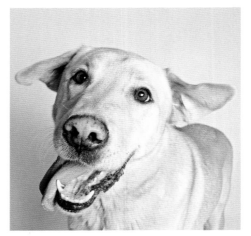
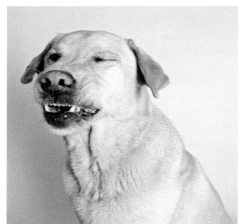
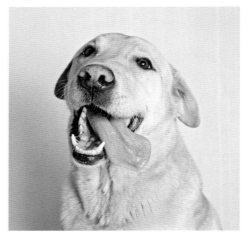

ZEPHER

At ten years old, Zepher landed at the shelter when his owner lost his home. This aged-to-perfection Lab was a real people pleaser who got along great with everyone he met. Zepher also had a love for tennis balls, swimming, and leisurely walks at sunset. His happily-ever-after moment happened when he met a new family to spend his golden years with. **Adopted 10/10/15**

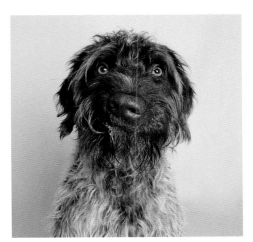
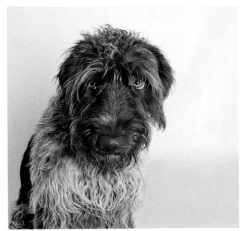
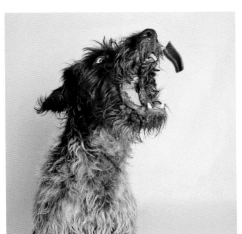
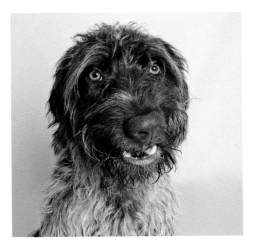

KODA

Koda ended up at the Humane Society of Utah when his former owners decied they no longer had the time to care for him. This athletic two-year-old German wirehaired pointer wooed potential adopters with his golden eyes and charming personality. It all worked out for the charismatic Koda, who landed in his dream home. **Adopted 8/04/15**

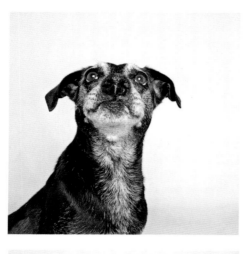
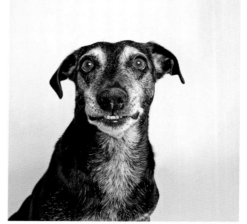
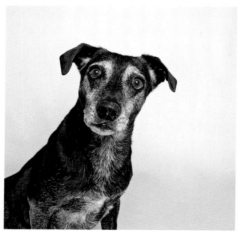
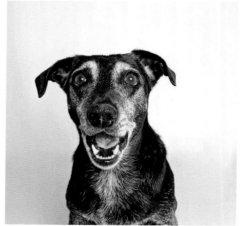

SKUNK

Good things come in small packages, and Skunk was no exception to this rule. The seven-year-old mixed-breed pup was smart, lovable, and well mannered. Staff at the Humane Society of Utah enjoyed every moment with this boy, who transferred in from another shelter. It didn't take long for someone to see all the spark and joy Skunk could bring to their home. (Maybe they even renamed him.) **Adopted 10/06/15**

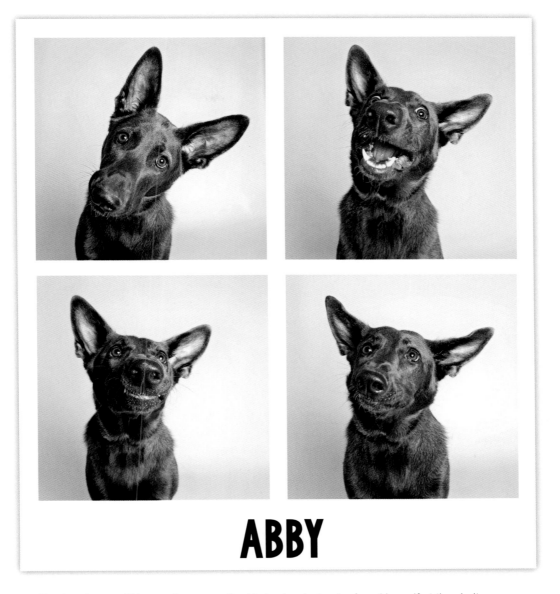

ABBY

This knockout is Abby, an eleven-month-old shepherd mix who found herself at the shelter when her owner's landlord gave her the boot. She was smart, loyal, and a bit leery of strangers but warmed up to people after just a few minutes of attention. She found her best friend.
Adopted 9/11/15

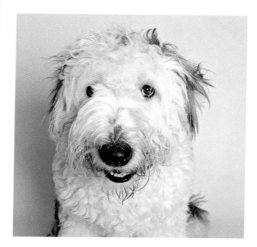 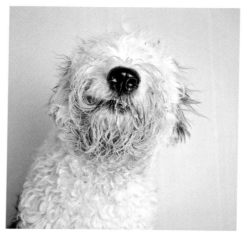

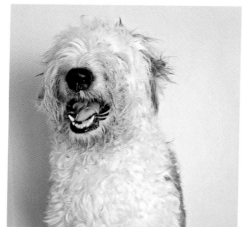 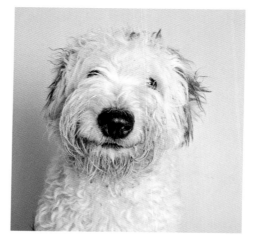

BLISS

Two-year-old Bliss, an Old English sheepdog, was a big girl who took her herding duties very seriously. A bit too seriously for her former family. Big, goofy, and in need of an experienced owner, Bliss was part of a special program at the Humane Society of Utah designed to help place dogs that needed a little extra training and understanding. She found her perfect match, who drove all the way from California to get her! **Adopted 10/05/15**

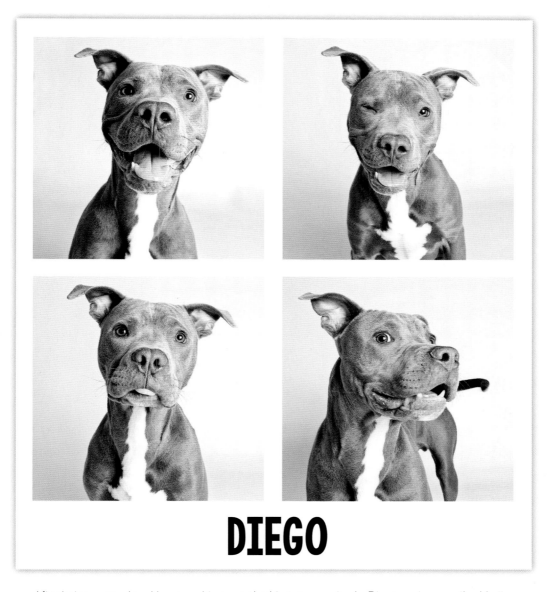

DIEGO

After being surrendered because his owner had too many animals, Diego, a nine-month-old pit bull terrier, knew he had to turn on the charm to compete. If his smile, wink, or puppy dog eyes didn't win you over, surely his uncontrollable wiggle-butt would. It worked. Diego was out of the shelter in two days! **Adopted 7/02/15**

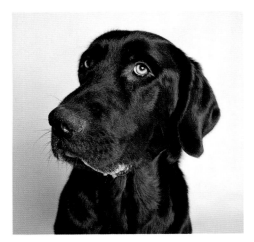
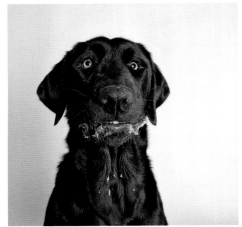
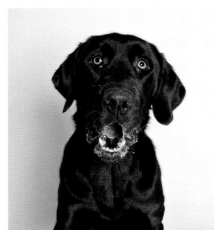
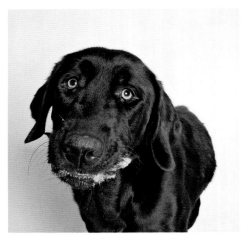

RUFFIAN

With puppy dog eyes that could melt your soul, Ruffian got another chance at life after transferring in from an Idaho shelter. You would never guess this big boy was only two years old; after all, he acted like a true gentleman. Ruffian knew a couple commands, walked nicely on a leash, and did well with the other dogs he met at the shelter. Of course, it didn't take long for someone to fall head over heels for this lovable Lab. **Adopted 10/10/15**

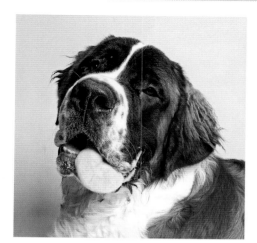
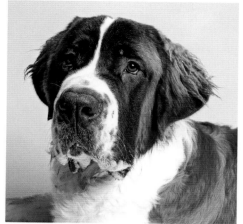
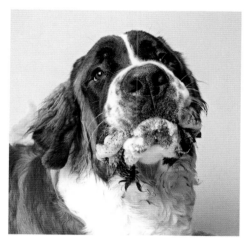
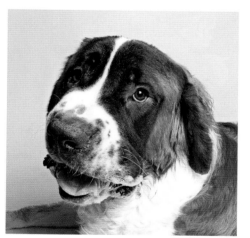

ATTICUS

Atticus, a seven-month-old Saint Bernard, was surrendered because his owners did not have the time to take care of him. The jolly giant was well trained, lovable, gentle, and great with people. Naturally, families were lining up to adopt this humongous pup. **Adopted 8/31/15**

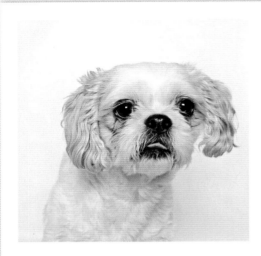
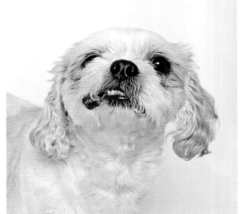
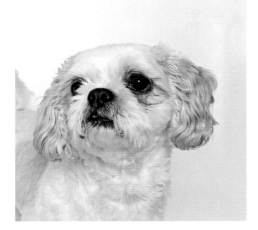
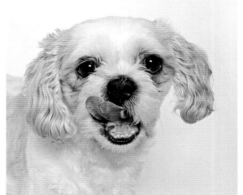

RUDY

Rudy came to the shelter when his former owners ran into some problems. This three-year-old shih tzu was a sweet and petite fella who enjoyed the mature crowd. Rudy knew his worth as a canine king; he just wanted to be treated like royalty. After spending a little time in a foster home, he found a home of his very own! **Adopted 10/15/15**

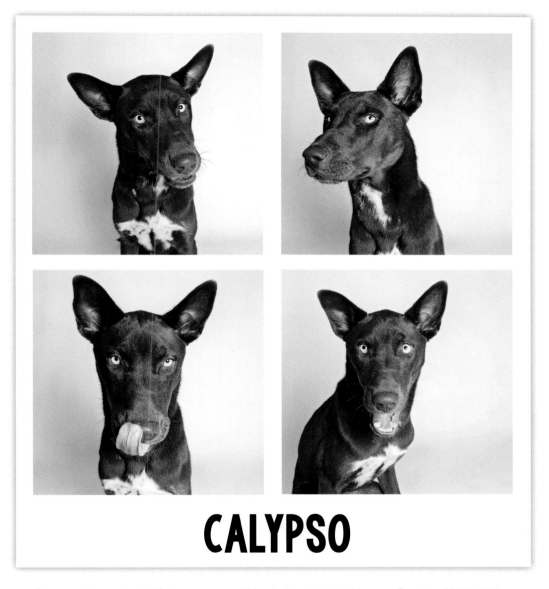

CALYPSO

Owner problems landed Calypso, a year-old husky blend, at the Humane Society of Utah. With a heart of gold, Calypso was eager to please and ready to learn. She was an energetic pup looking for a family that could keep up. She found one! **Adopted 10/02/15**

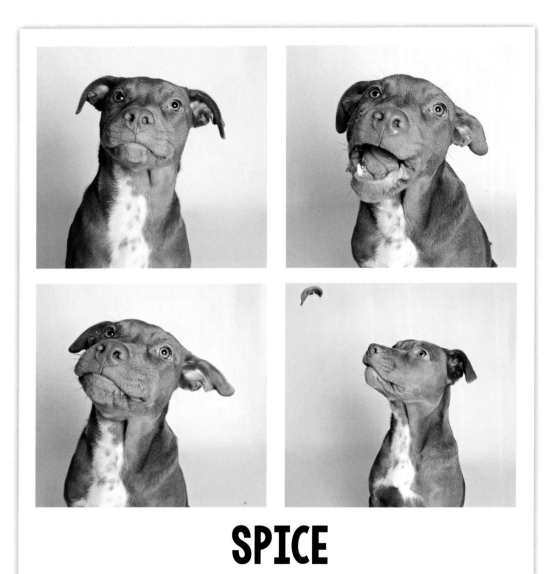

SPICE

What's that saying? Sugar and spice make everything nice? Spice certainly wouldn't argue! This adorable six-month-old pit bull terrier puppy came from a California shelter looking for her second chance at life. It's no wonder this little cupcake found her forever home in a very short time! **Adopted 9/30/15**

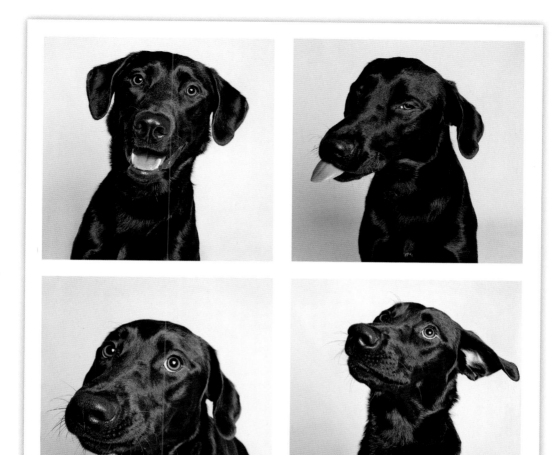

BOOMER

Boomer, a year-old black Lab mix, was surrendered to the Humane Society of Utah for having more energy than his former owners could handle. Bursting at the seams with goofy and excited playfulness, Boomer just needed an active family that could keep up. He found one! **Adopted 7/28/15**

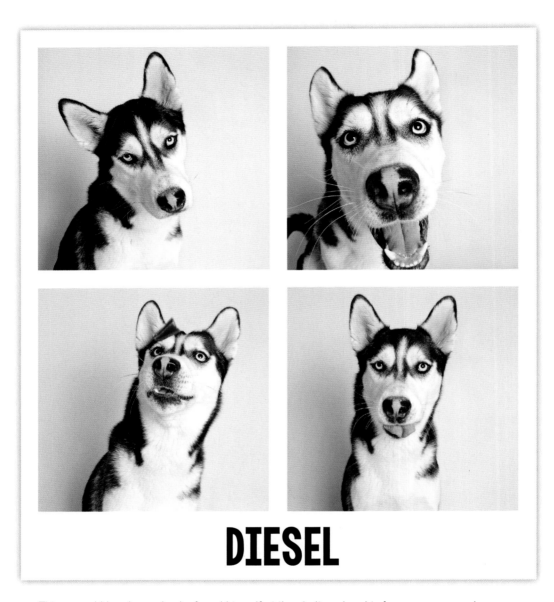

DIESEL

This year-old handsome husky found himself at the shelter when his former owners no longer had the time to care for him. Full of get-up-and-go, Diesel already knew his basic commands, was house-trained, and got along well with other dogs and cats. This dapper gent found his forever family in one day! **Adopted 8/24/15**

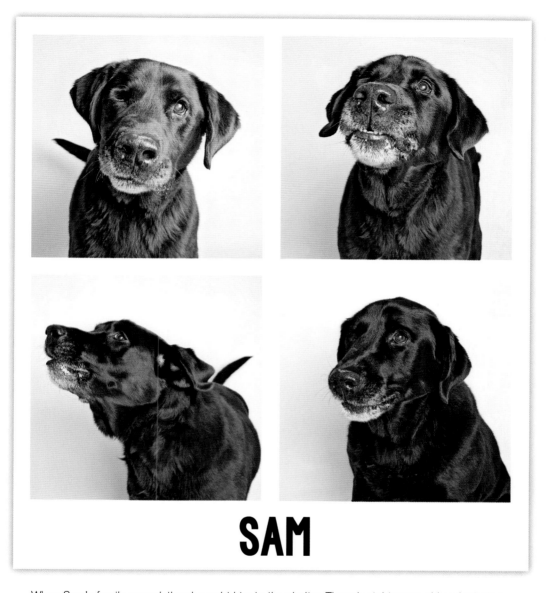

SAM

When Sam's family moved, they brought him to the shelter. Though eight years old and missing an eye, this black Lab didn't miss a beat. His energetic and playful spirit won over all the staff and volunteers. Sam's champion ball skills and fetching abilities won him a home of his very own. **Adopted 8/03/15**

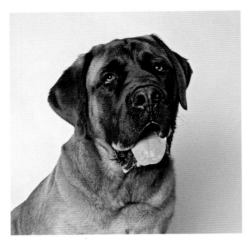
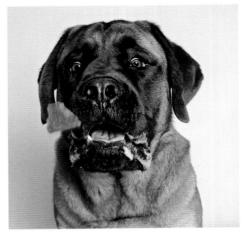
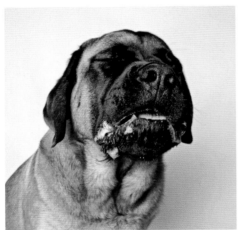
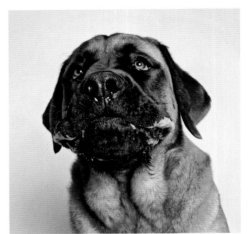

SULLY

A hundred-pound puppy—that was Sully, a seven-month-old mastiff mix! He found himself at the shelter when his family moved and couldn't take him with them. After a brief stint in a foster home while being treated for kennel cough, Sully "the love bug" found his dream family!
Adopted 6/04/15

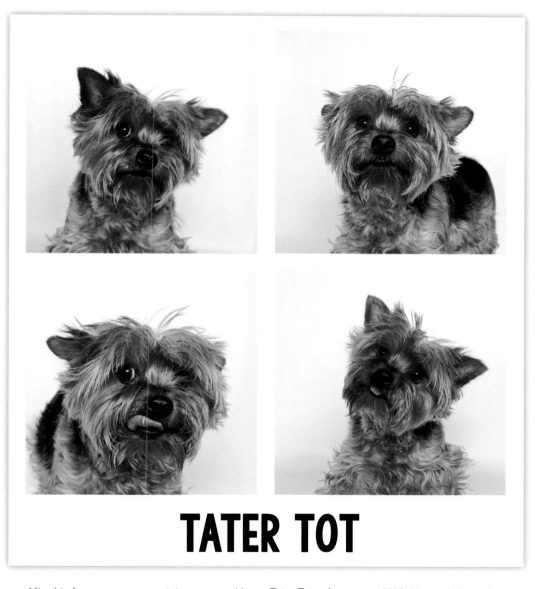

TATER TOT

After his former owners ran into some problems, Tater Tot, a four-year-old Yorkie, ended up at the shelter. This fun-loving pint-sized prince had no trouble charming everyone he met. After two days in the shelter, he was adopted! **Adopted 8/15/15**

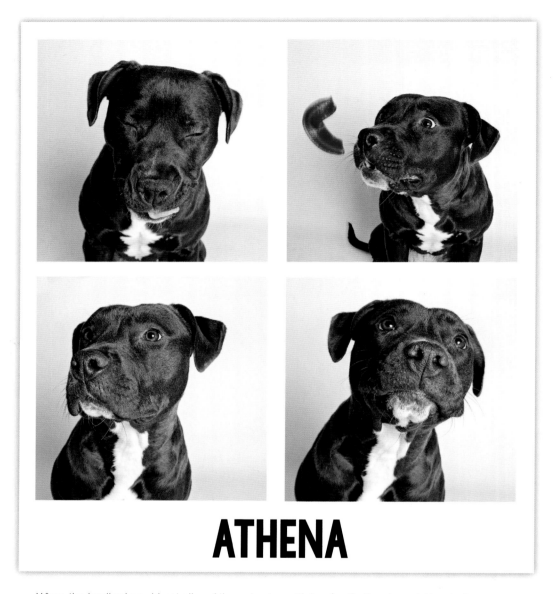

ATHENA

When the landlord would not allow Athena to stay with her family, they brought her to the shelter. A real people pleaser at just ten months old, Athena was hard not to adore. This pit bull terrier mix could be found playing fetch with volunteers and snuggling up afterward. After a month of waiting, she found the perfect family of her very own. **Adopted 9/22/15**

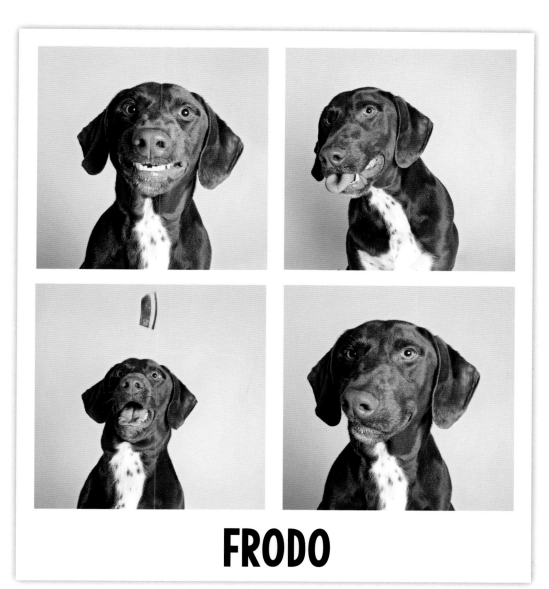

FRODO

Frodo's family moved and was not able to take him along, so they brought him to the Humane Society of Utah. Talk about a big boy with an even bigger personality! Frodo, a three-year-old pointer blend, had a lot going for him. He knew a few commands, had good house manners, and got along great with other dogs, kids, and even cats! He found what he was looking for: a family of his own. **Adopted 10/08/15**

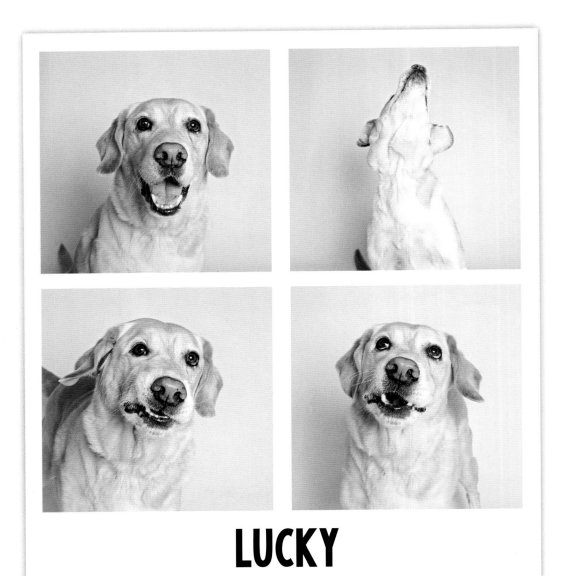

LUCKY

Owner problems landed Lucky, a seven-year-old Lab, at the Humane Society of Utah. After some medical concerns, he spent some time in a foster home, where he enjoyed car rides, tennis balls, and ample amounts of love! Lucky got adopted! **Adopted 10/20/15**

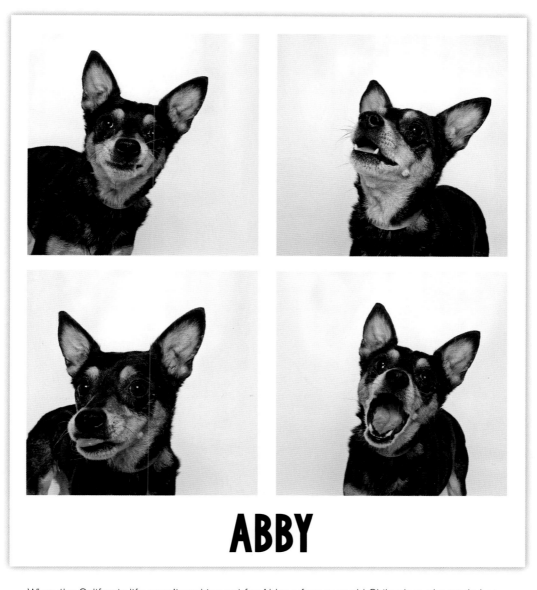

ABBY

When the California life wasn't working out for Abby, a four-year-old Chihuahua, she made her way to Utah for her second chance. Abby was the perfect combination of sassy and sensitive. She loved attention from people, and was looking for a lap to call her own. She found it and now warms laps in her new home. **Adopted 10/09/15**

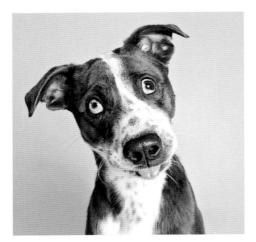
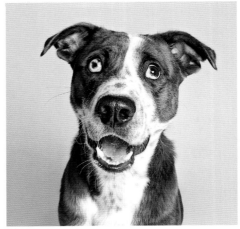
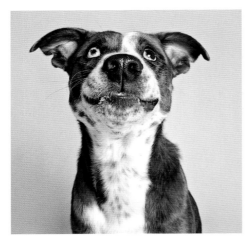
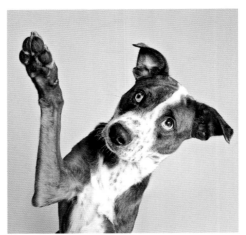

BUZZ

Have you heard all about the Buzz? If not, let us tell you all about him! This stunning one-and-a-half-year-old mutt was full of spunk and playful smarts! He already knew a few commands, such as sit and shake. Plus, he did well with his kennel mates. He came to the Humane Society of Utah from another shelter, and much about his history was unknown. It wasn't long before someone snatched up this distinctive-looking pup. **Adopted 8/01/15**

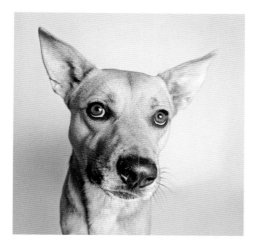
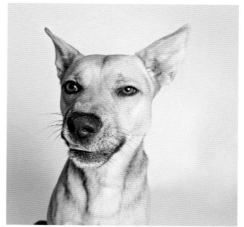
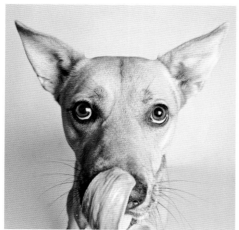
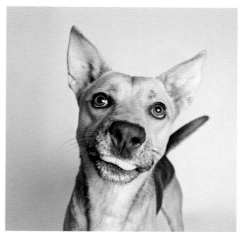

JASPER

After being left at the shelter, Jasper was dreaming of a bright future! A little shy and unsure after spending the first eleven months of his life outside, he quickly warmed up with a little love and affection. This shepherd mix was eager to learn for a tasty morsel, figuring out how to sit and stay in mere minutes. Lucky for Jasper, he was adopted by a family that promised to bring him inside as part of the family! **Adopted 10/11/15**

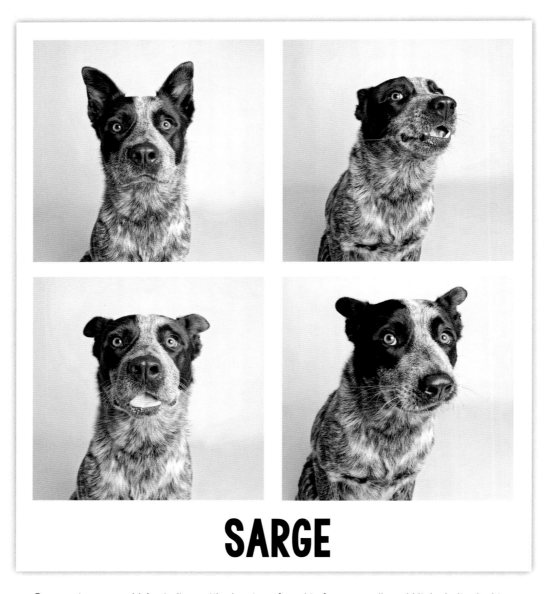

SARGE

Sarge, a two-year-old Australian cattle dog, transferred in from a small rural Utah shelter looking for his second chance at life. Sarge quickly proved he was not afraid to get his paws muddy and get to work. He was quick to learn, well trained, and very obedient—not to mention handsome. Someone agreed and took this dapper gent home. **Adopted 8/25/15**

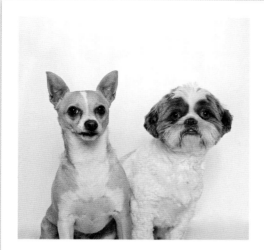
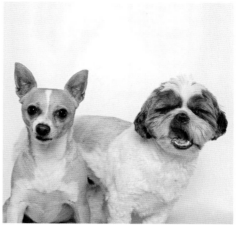
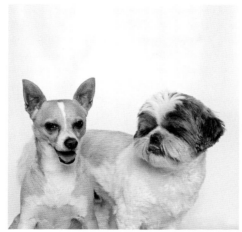
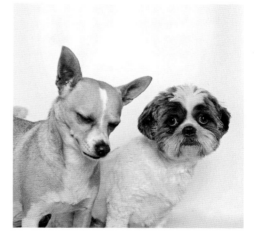

ROSCOE AND DAKOTA

This bonded pair wound up at the Humane Society of Utah after their owner could no longer afford to keep them. These three-year-old buddies grew up together, and the shelter staff promised their former owner they would be adopted together. You couldn't pick one up without the other following your feet. These boys shared food and treats and snuggled up together while taking naps. The promise was kept and they were adopted together! **Adopted 10/08/15**

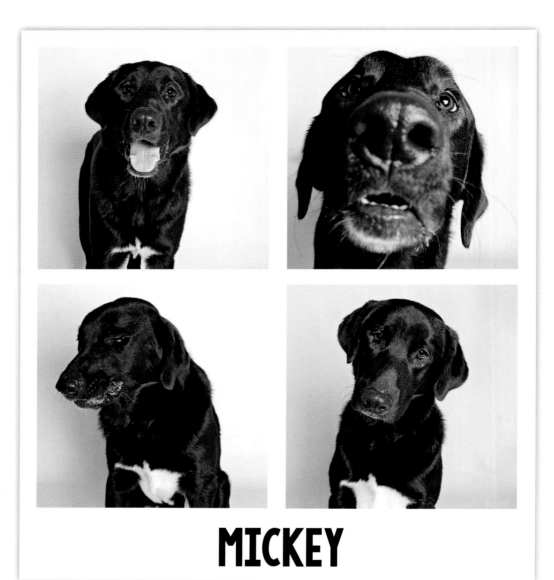

MICKEY

This ray of sunshine was brought to the shelter when his owners no longer had time for him. Mickey, a ten-month-old Lab blend, was just a big puppy in need of hugs and a playmate. After spending the first ten months of his life outside, he wanted nothing more than to hang inside with his friends. He loved playing with squeaky toys and attempting to sit in the staff members' and volunteers' laps. Mickey got the second chance he deserved with his new family. **Adopted 10/22/15**

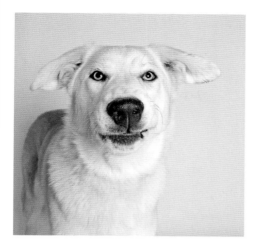
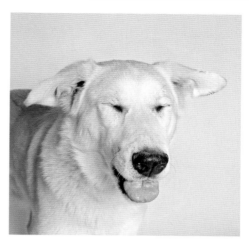
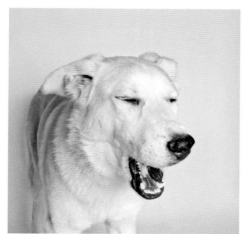
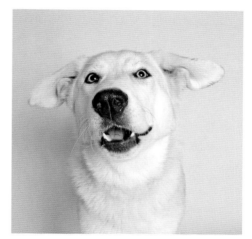

JUNO

Dumbo the elephant had nothing on seven-month-old husky mix Juno. She could use those ears to pick up everything from aliens to would-be burglars. Juno found herself at the shelter when her family no longer had the time to care for her. This playful pup was full of flair and ready to join a family on all their outdoor adventures. Someone agreed and took this delightful gal home! **Adopted 9/09/15**

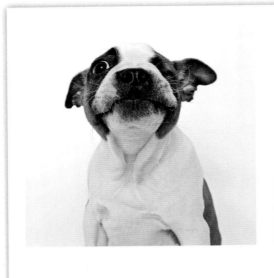
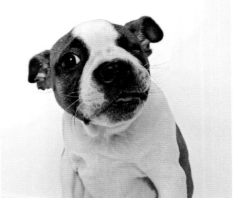
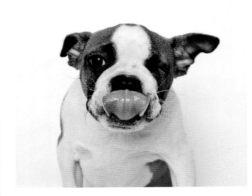
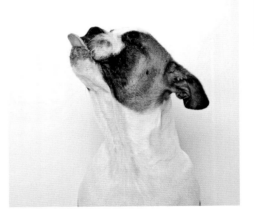

WALLACE

Wallace found himself in a Los Angeles shelter after being surrendered with a broken leg and an eye injury at just three months old. Because that shelter did not have the resources to fix his leg, Wally was transferred to the Humane Society of Utah. Because his leg could not be saved, he became a "tripod," but none of that affected his great personality. After seven weeks in foster care, Wally was adopted! **Adopted 9/04/15**

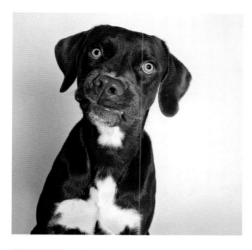
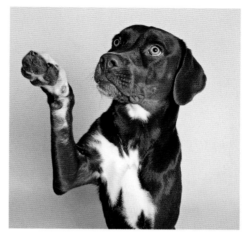
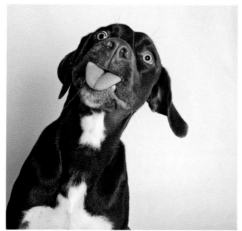
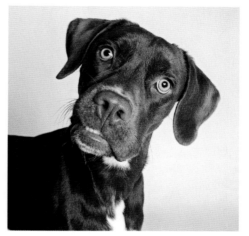

MECCHY

Mecchy, a high-octane ten-month-old pup, was surrendered to the shelter for having more energy than his family could handle. This pointer mix was bursting at the seams with excited and eager-to-please enthusiasm. Mecchy was great with other dogs, house-trained, and knew his basic commands. What he needed was an adventurous family to take him on all their explorations. He got just that! **Adopted 10/01/15**

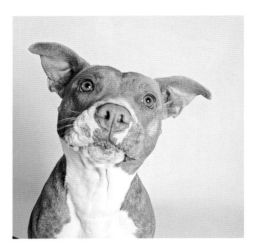
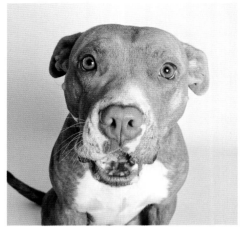
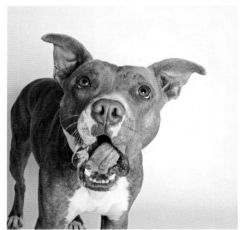
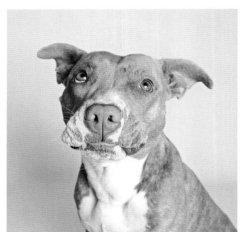

JASMINE

Jasmine ended up in the shelter after her owner passed away. Earnest and affectionate, Jasmine was already house-trained and played well with other dogs and kids. Jasmine was looking for another family to call her own. She patiently and quietly waited until just the right family arrived to give her a home. **Adopted 10/16/15**

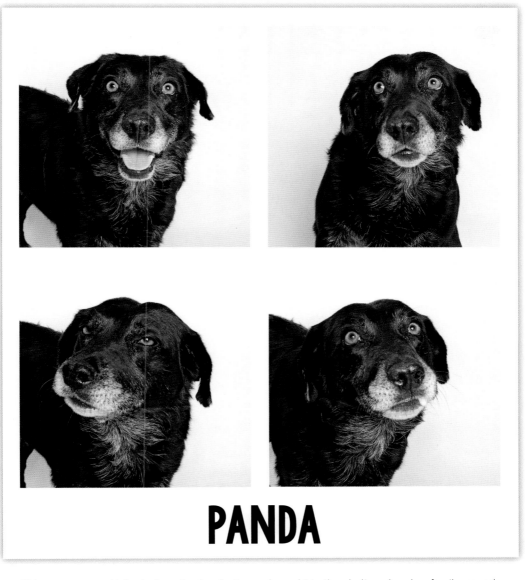

PANDA

This seven-year-old Australian shepherd mix was brought to the shelter when her family moved. Smart as a whip, Panda knew her basic commands and got along great with everyone. She even appeared in an Instagram ad for Beggin' Strips dog treats. Unfortunately, she developed a mysterious illness and was placed in a foster home so she could be diagnosed and treated. After spending some time in the foster home, she found her forever family. **Adopted 1/02/16**

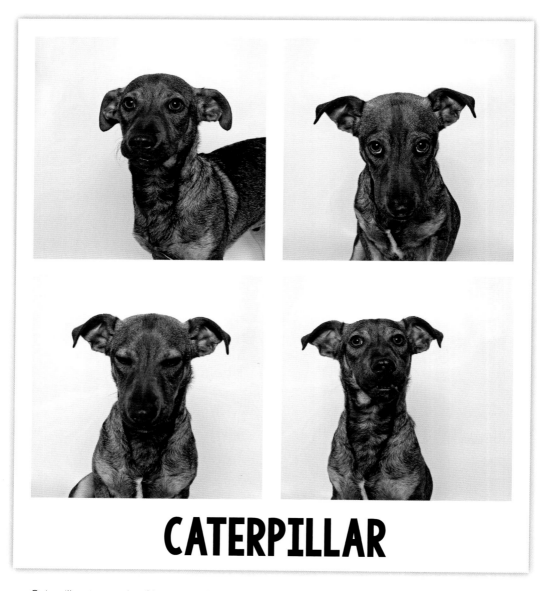

CATERPILLAR

Caterpillar was made of two parts short, three parts smiles, and a whole lot of goodness! He came all the way from a Los Angeles shelter to get his second chance at life. At four months old, this adorable mega mutt was anyone's dream come true. He even achieved fame before he was adopted, when he appeared in an Instagram advertisement for Beggin' Strips dog treats. **Adopted 9/23/15**

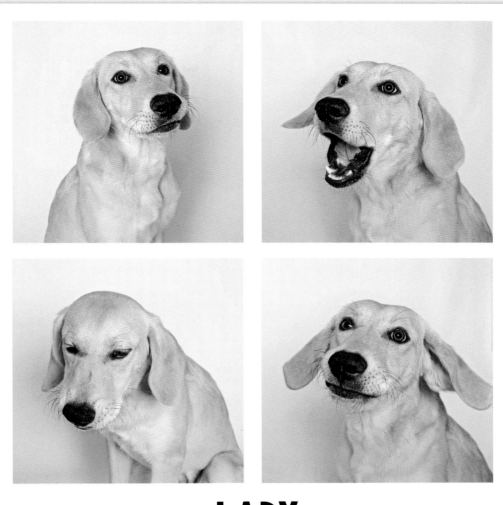

LADY

A tomboy at heart, this little Lady was looking for a life partner that loved adventure. Morning runs, trips to the dog park, or serious hikes in the mountains, Lady had you covered. The eight-month-old Lab got her second chance at life after transferring in from a rural Utah shelter. This all-terrain pup was ready for a family of fellow explorers. She found them! **Adopted 10/13/15**

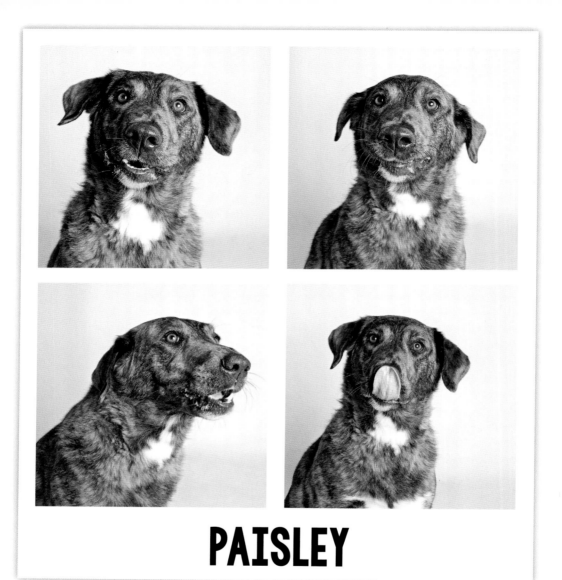

PAISLEY

This people pleaser was always upbeat and promised to make the perfect coffee, park, or lunch date. At two years old, the versatile and well-mannered Paisley wouldn't dream of leaving the toilet seat up or canceling plans at the last minute. Paisley found her perfect companion when she was adopted. **Adopted 10/31/15**

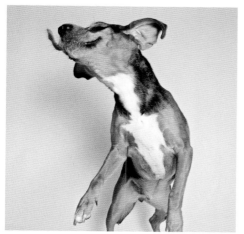
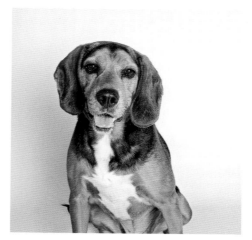

THUNDER

Fun, fun, fun: That's what Thunder was all about. This exuberant six-year-old hound blend wanted to join everyone on all their adventures, whether in the mountains, at the park, or just running through the neighborhood. Thunder was house-trained and enjoyed the company of other dogs, kids, and even cats! A hound-loving family snatched up the pint-sized pup. **Adopted 8/22/15**

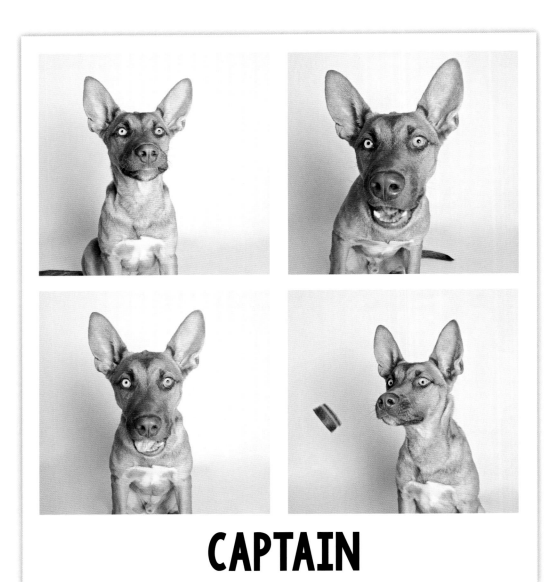

CAPTAIN

Captain was the perfect blend of working breeds. This six-month-old husky shepherd mix relocated to the Humane Society of Utah from a California shelter. Don't let his age and looks fool you: Captain was the real McCoy. He mastered his sit, lie down, and stay commands while at the Humane Society of Utah. What's next for Captain? Ask his new owners! **Adopted 8/28/15**

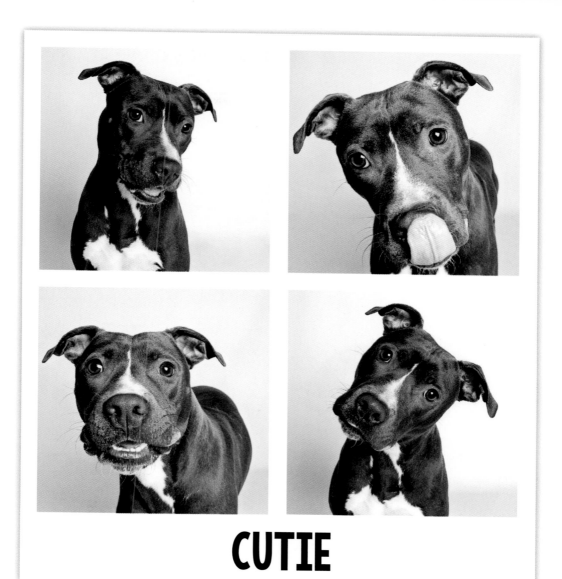

CUTIE

Meet Cutie, a one-and-a-half-year-old pit bull mix who was seeking her human soul mate when she arrived at the Humane Society of Utah from another shelter. Cutie turned up the charm using her winning combination of supermodel looks and endless energy—and it worked!
Adopted 8/02/15

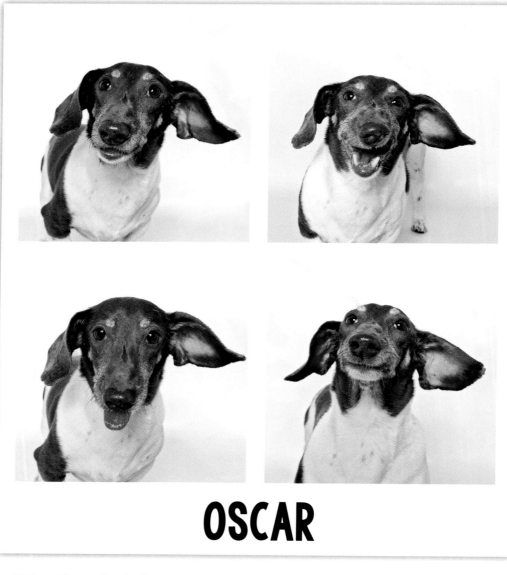

OSCAR

With a million-watt smile, Oscar, a seven-year-old dachshund, wasn't going to let being in a shelter get him down. His former family no longer had the time to care for Oscar, so he was looking for one that would appreciate his playful and gentle essence. He found them. **Adopted 7/23/15**

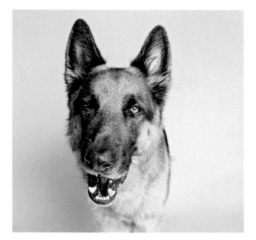
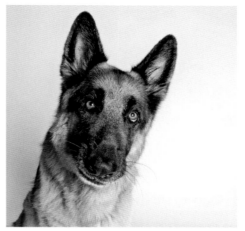
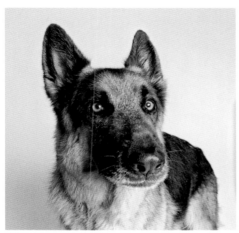
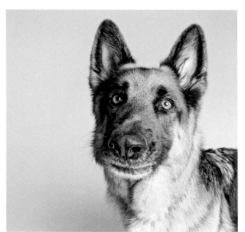

BRUNO

No, it's not Rin Tin Tin . . . it's Bruno, a loyal four-and-a-half-year-old German shepherd who could care for the kids, mind the cats, and always use his manners in the house. Handsome Bruno made a statement when he entered the room, and it was not long before he was adopted into a loving home of his own. **Adopted 9/22/15**

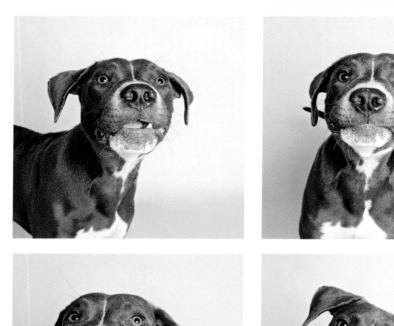
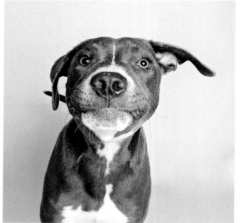
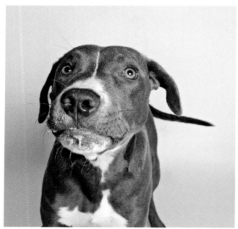
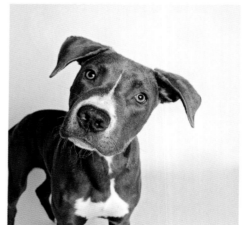

CHOMPER

Don't let his name fool you. Chomper, a six-month-old pit bull terrier, is really a lover. This cuddlebug was willing to help his new owners get through the saddest movies and the chilliest nights. He came from a California shelter and continues to work on his master's degree in canine snuggle therapy in his new home. **Adopted 8/28/15**

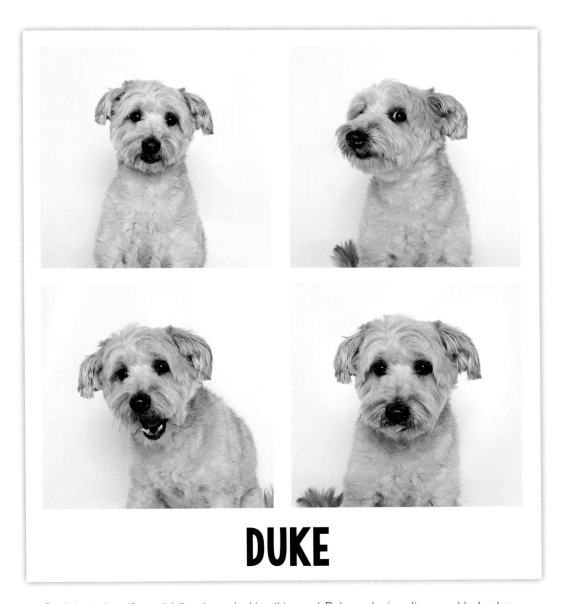

DUKE

Don't be jealous if you didn't wake up looking this good. Duke, a charismatic year-old wheaten terrier, works hard to be this adorable. He was surrendered to the shelter for not being completely house-trained. Duke tried his best to please, even standing on his hind legs and clapping his fronts paws on command. He was just looking for a family willing to give him a refresher course on house manners. Luckily, he found one. **Adopted 10/17/15**

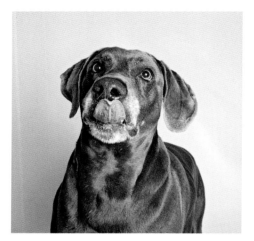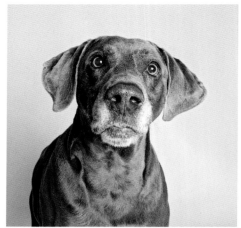
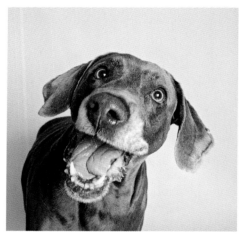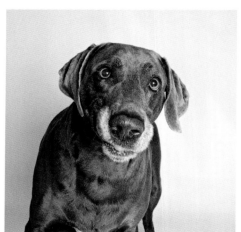

BEAUREGARD

Beauregard wasn't looking for an army to lead, just a family to snuggle with at night. This dashing seven-year-old Weimaraner ended up at the Humane Society of Utah for reasons unknown. Like any true gent, Beauregard could entertain, either by making you laugh or by playing with tennis balls. After a month-and-a-half stay at the Humane Society of Utah, Beauregard found his forever home! **Adopted 10/28/15**

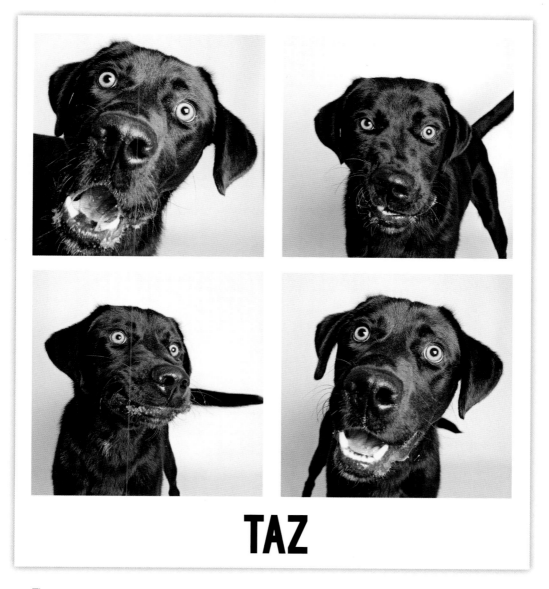

TAZ

This captivating comedian's routine had all the staff members at the Humane Society of Utah in stitches. Taz, the year-old Lab mix, got his second chance at life after transferring in from an overcrowded shelter. It didn't take long for Taz to be named the funniest pup on the block. His new owners couldn't agree more! **Adopted 10/10/15**

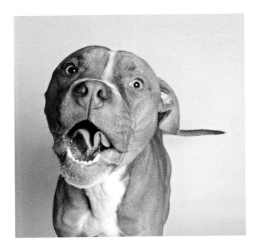
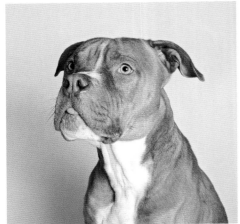
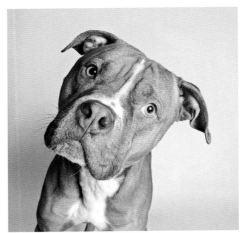
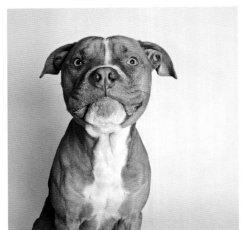

BRUNO

A velvety pile of perfection, Bruno loved to cuddle, gently take treats from fingertips, and sit in laps. The year-and-a-half-old pit bull terrier landed at the shelter when his former family moved and could not take him along. Bruno knew his basic commands, was house-trained, and got along well with kids and other dogs. It was no surprise that it only took a day in the shelter before he found a new home. **Adopted 11/05/15**

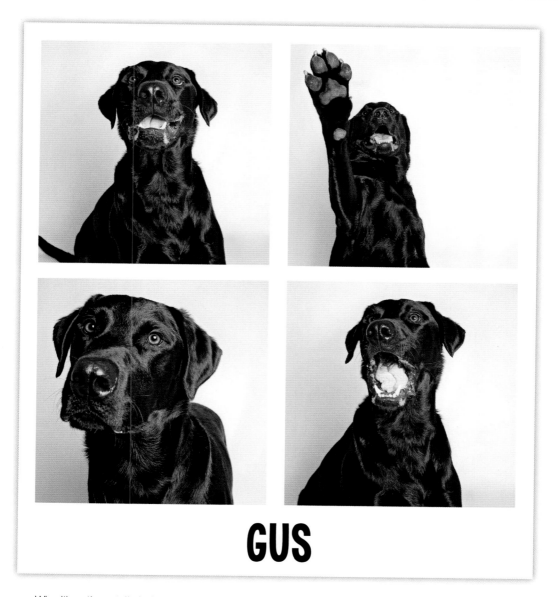

GUS

Who likes them tall, dark, and handsome? How about good looks and a great personality to boot? Gus wasn't letting the fact that he was left at the shelter get him down. Yep, we aren't bragging when we say Gus, a two-year-old Lab, was all that and more. His new owners agreed.
Adopted 9/04/15

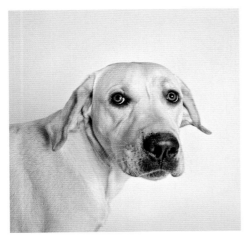
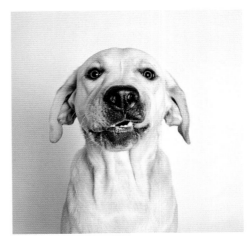
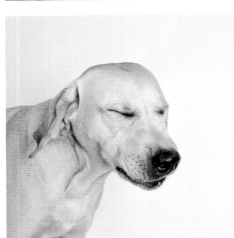
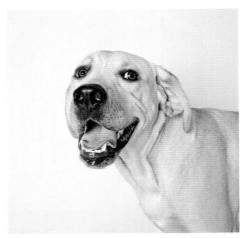

HENLEY

Owner problems landed Henley, a nine-month-old yellow Lab, at the shelter. Henley was your typical Lab: warmhearted, good-natured, and intelligent. But like any puppy, he was full of excited energy and was looking for a family that had as much energy as he did. Henley found it!
Adopted 10/08/15

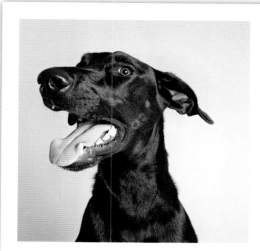
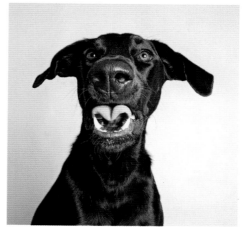
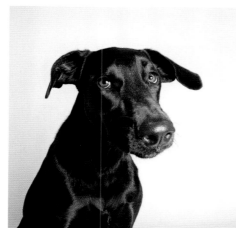
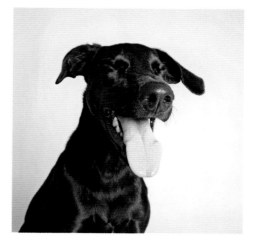

FRANKIE

Like any dapper gent, Frankie the year-and-a-half-old Doberman pinscher was true to his breed. Handsome, smart, and loyal were just a few words used to describe him. Frankie already knew his basic commands, walked well on a leash, and was house-trained. He was brought to the shelter when another pet in the family didn't get along with him. Frankie was adopted in just four days. **Adopted 9/27/15**

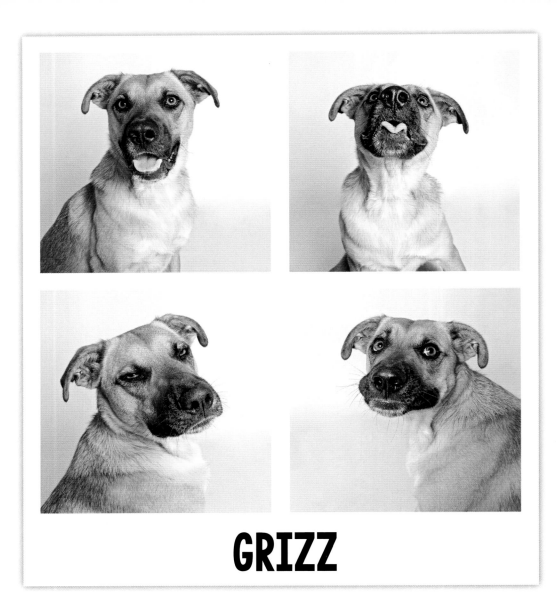

GRIZZ

This year-old herding dog mix wound up at the Humane Society of Utah after being transferred in from a rural Utah shelter. Grizz was the smartest pup in the place. Working with staff and volunteers he learned to sit, stay, and lie down in his week at the shelter. **Adopted 9/05/15**

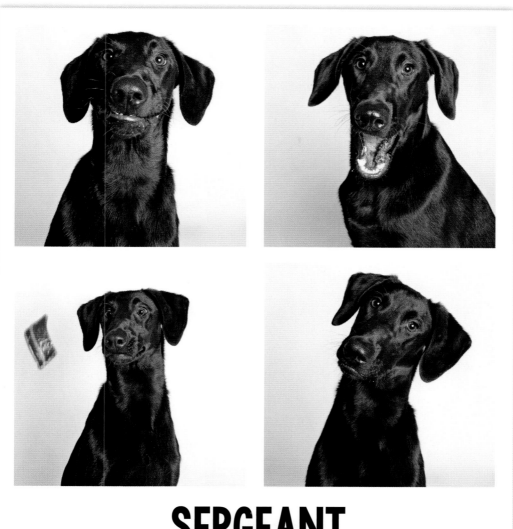

SERGEANT

A six-month-old puppy full of knock-knock jokes—that was Sergeant the Lab! A class clown who brought out the giggles in everyone, Sergeant was a star in his own right. He wound up at the shelter because he was too active for his previous owners. This comic was on the search for an active clan that would enjoy his energy. Luckily for Sergeant, he found a family that embraced all of his labtastic traits. **Adopted 9/16/15**

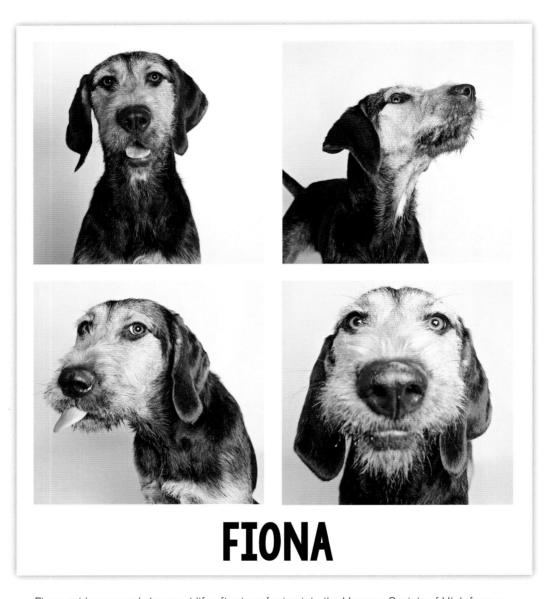

FIONA

Fiona got her second chance at life after transferring into the Humane Society of Utah from a rural shelter. She may have only been a year old, but this Airedale terrier blend was regal and sophisticated. This affectionate, fuzzy lady loved sitting right next to her favorite people. Lucky for her, she found them in a matter of days. **Adopted 9/05/15**

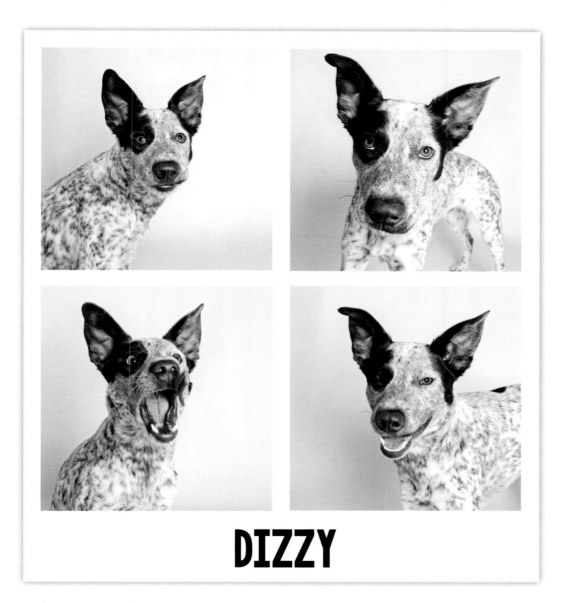

DIZZY

At just a year old, Dizzy, a gossip-loving Australian cattle dog, was surrendered for being too hyper. This spirited pup was house-trained and good with kids and other dogs. All she needed was a family that could include her on all their daily adventures and listen to all her stories, because she loved to tell them! She found a family that appreciated all of her herding-dog antics! **Adopted 9/05/15**

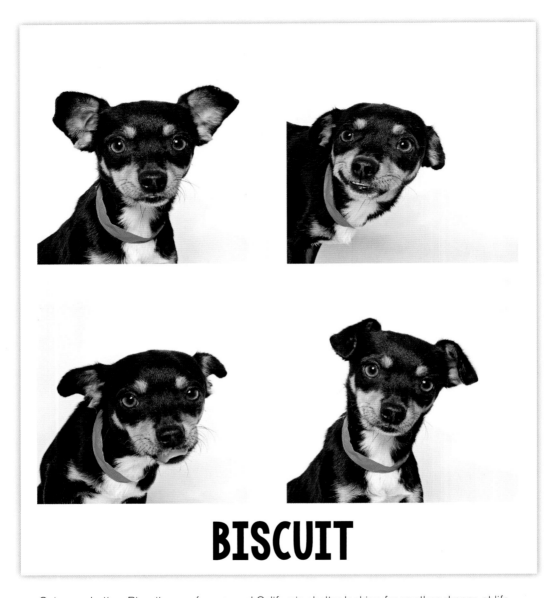

BISCUIT

Cute as a button, Biscuit came from a rural California shelter looking for another chance at life. An adorable little nugget who loved to be toted around, Biscuit, a year-old Chihuahua mix, was the definition of cuteness. In just a few days, someone else agreed! **Adopted 9/04/15**

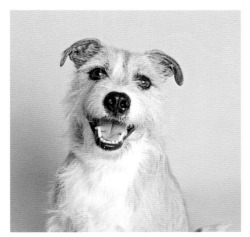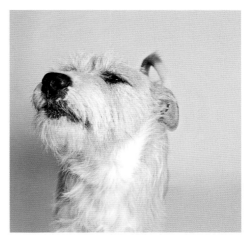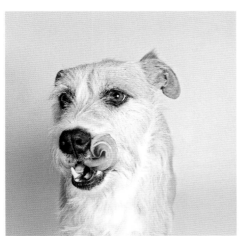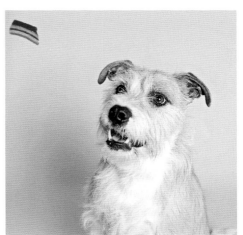

BELAINT

Belaint was brought to the Humane Society of Utah as a stray, so his history was a mystery. At about three years old, this border terrier mix was no stranger to people; he eagerly greeted everyone who approached his kennel. So naturally it didn't take long for someone to notice him and fall in love. **Adopted 10/25/15**

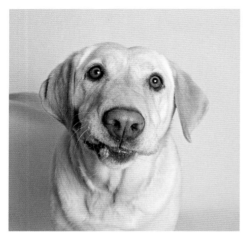
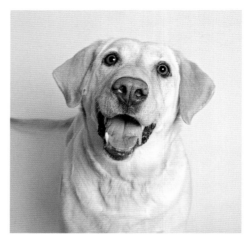
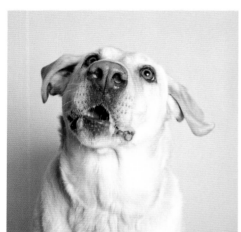
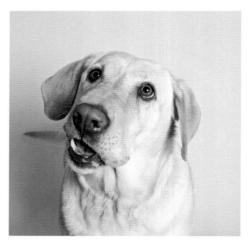

EMBER

Introducing the lovely golden goddess Ember, who came to the Humane Society of Utah from a rural shelter. It didn't take long for this smart cookie to put her looks and charm to work in her favor. She grabbed her new owners' attention just two days after arriving at the Humane Society! **Adopted 10/06/15**

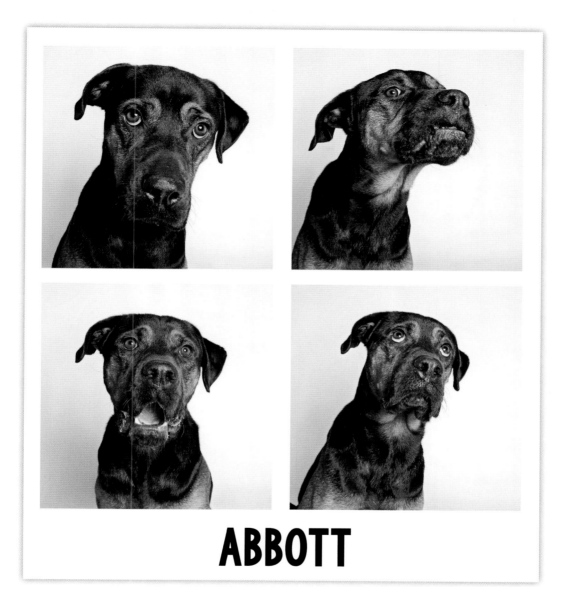

ABBOTT

Abbott was transferred in from a rural Utah shelter to the Humane Society of Utah for his second chance. This stoic two-year-old rottweiler blend was calm and quiet during his stay. His polite demeanor quickly won over the staff and volunteers. It did not take long for Abbott to find his forever home; he was adopted in just two days. **Adopted 9/27/15**

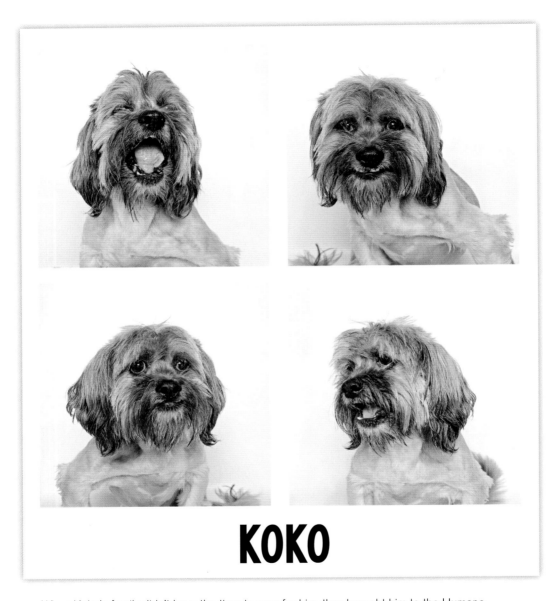

KOKO

When Koko's family didn't have the time to care for him, they brought him to the Humane Society of Utah. At seven years young, Koko was a dream to be around. He gladly entertained everyone he met with his silly shenanigans. He was already house-trained and got along great with other dogs, kids, and even cats! He got his happily-ever-after moment when he was adopted. **Adopted 8/15/15**

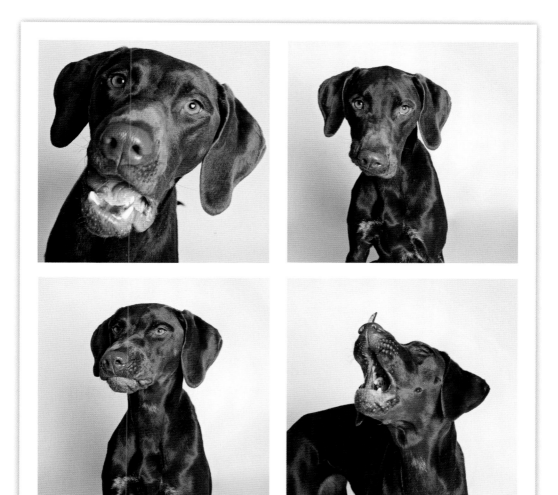

MIA

Anyone's dream girl, Mia, a one-and-a-half-year-old German shorthaired pointer, was smart, house-trained, and knew her basic commands . . . but kids weren't for her. She was looking for a mature household that was ready for grown-up adventures! She found them. **Adopted 11/09/15**

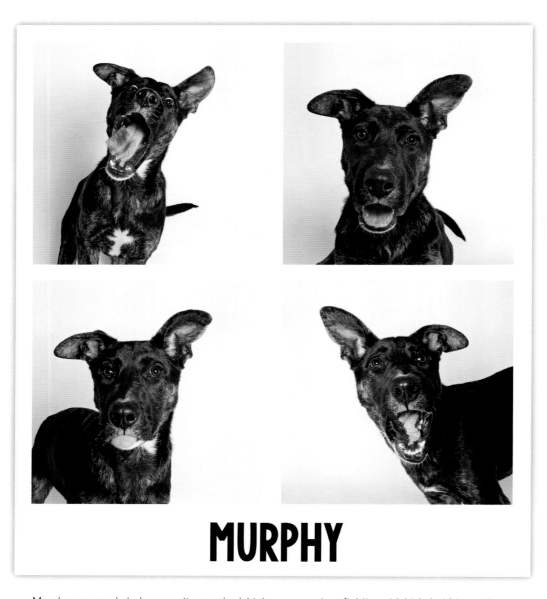

MURPHY

Murphy was ready to be an action-packed, high-energy, crime-fighting sidekick, but his previous owners didn't have the time to care for him. They did the next best thing and brought the five-month-old German shepherd mix to the shelter. This pup was always a step ahead of the rest: he already knew how to sit, stay, and lie down. An action hero appeared for this pup, and we hear it's a perfect match. **Adopted 10/13/15**

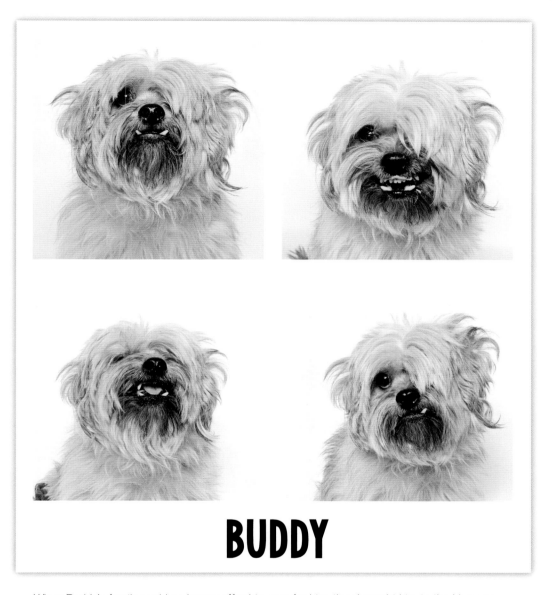

BUDDY

When Buddy's family could no longer afford to care for him, they brought him to the Humane Society of Utah. At eight years old, this one-eyed shih tzu was a champion lap dog. Affectionate and loyal, Buddy was also a master of detecting treats; if you had one he knew! He found his perfect match and was promised lots of lap time. **Adopted 8/14/15**

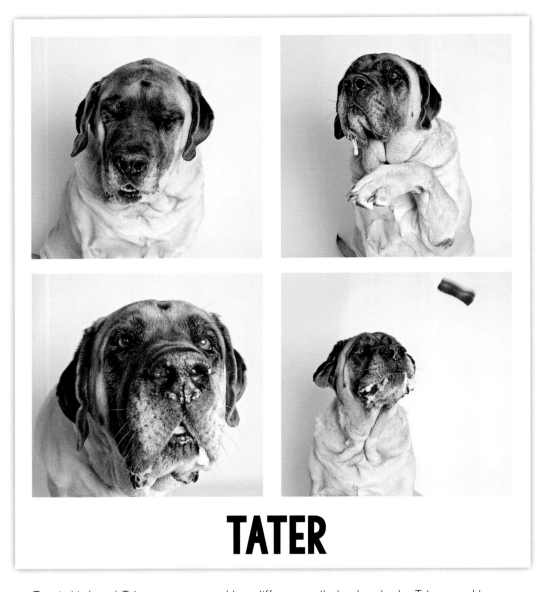

TATER

True to his breed, Tater, a seven-year-old mastiff, was gentle, loyal, and calm. Tater vowed to keep all your secrets and stick by your side on any walk. He was quite the social butterfly with people and other dogs during his stay at the Humane Society of Utah. Tater found the perfect family to spend his golden years with. **Adopted 10/15/15**

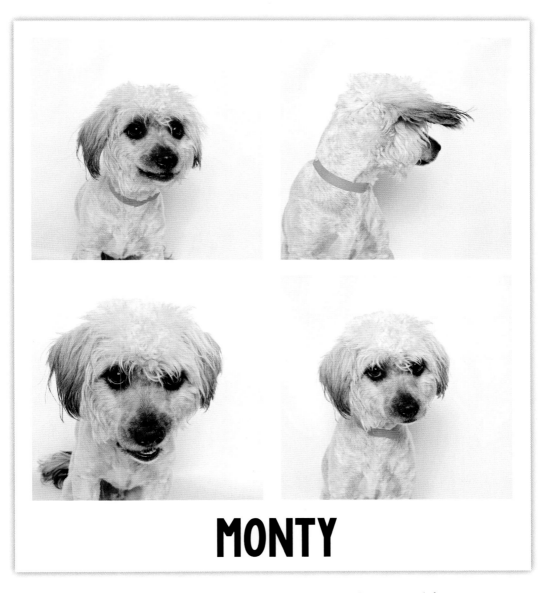

MONTY

Bad hair day? No such thing with Monty, a year-old poodle mix. When he wasn't fantasizing about becoming the next top model, he was dreaming of his very own family. Unfortunately, he came down with a cold, and his stardom aspirations had to be put on hold while he recuperated in a foster home. **Adopted 11/16/15**

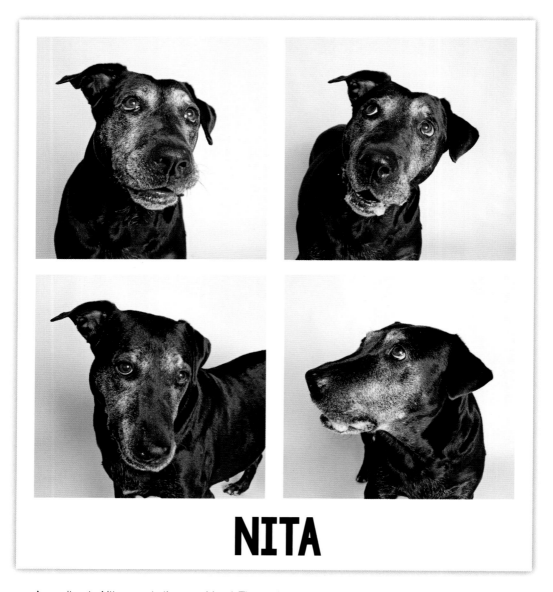

NITA

According to Nita, gray is the new blond. This eight-year-old Lab blend got along great with children, adults, and other dogs at the Humane Society of Utah. Mature and mellow, Nita was experienced in life but still enjoyed trotting and chasing balls. Her impeccable social skills helped her find a home of her very own! **Adopted 9/19/15**

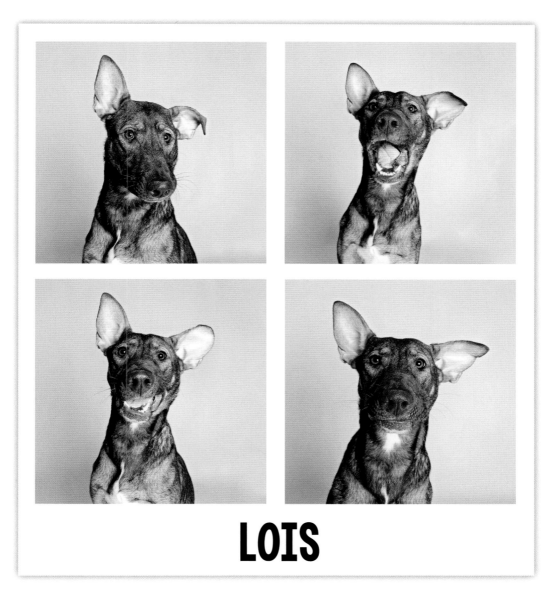

LOIS

Power up your jet pack and join Lois on a warp-speed adventure! Lois was a high-octane pup who doesn't slow down for much. Brought to the shelter for being destructive, Lois simply needed an active partner to help tire her out. This year-old German shepherd mix found just that! **Adopted 10/14/15**

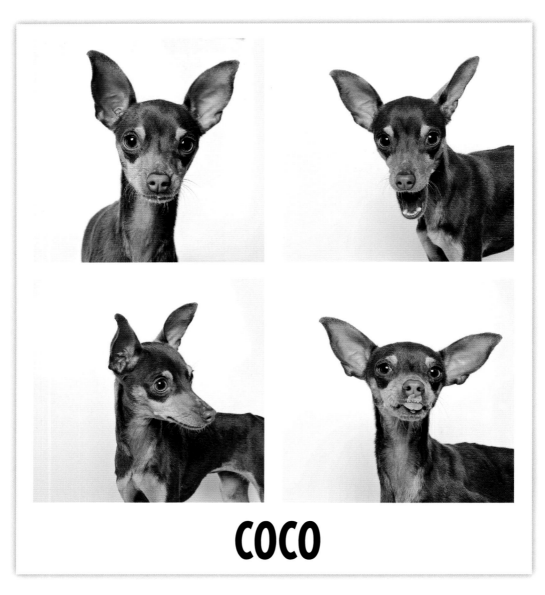

COCO

Meet the sweet and petite Coco, a year-old miniature pinscher mix who transferred to the Humane Society of Utah from a shelter in Idaho for another chance at life. This prim and proper princess was shy at first, but those who were patient were repaid tenfold in delicate little kisses. Coco got the second chance she was looking for! **Adopted 7/29/15**

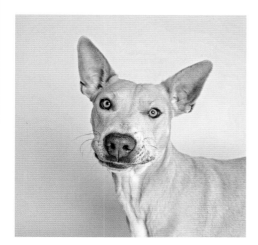
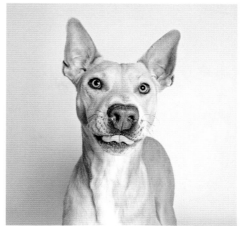
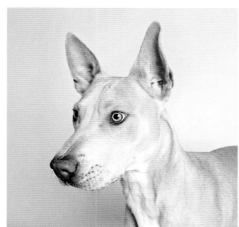
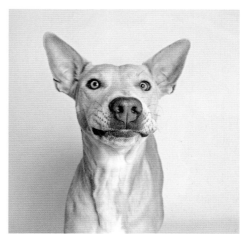

MERLIN

Merlin strutted into the Humane Society of Utah looking as though he'd just left guard duty at an Egyptian pharaoh's tomb. The ten-month-old Carolina dog mix was transferred from a small, rural Utah shelter. He was truly unique and respectable, and he got the second chance at life he deserved. **Adopted 8/25/15**

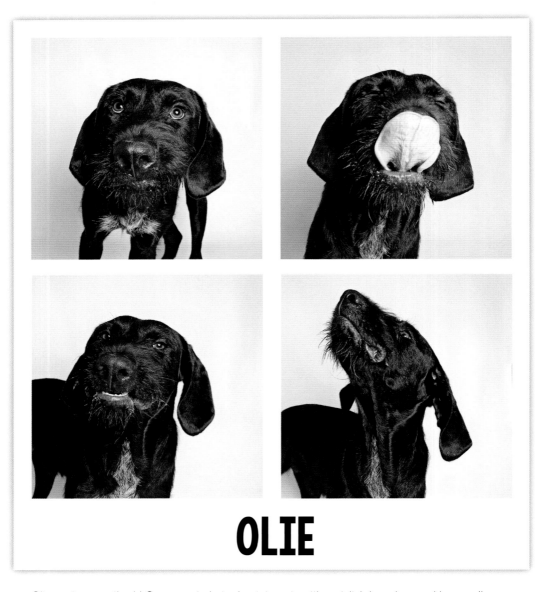

OLIE

Olie, a nine-month-old German wirehaired pointer mix with a stylish beard, craved long walks and lots of toys. He was brought to the shelter because he chewed up things he shouldn't have when he got bored. Olie had a great personality; he just needed some help and guidance learning how to channel his energy in more positive ways. He was looking for a running, hiking, walking, cycling, or even swimming buddy—and he found his perfect match! **Adopted 10/20/15**

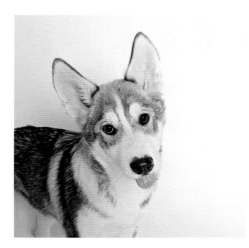 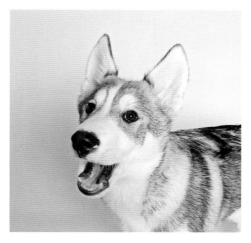

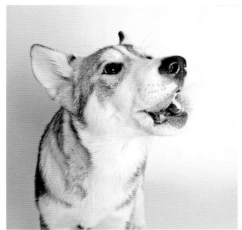 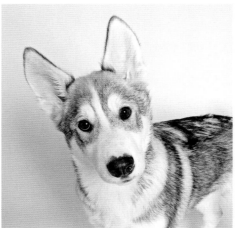

MISSY

A ball of furry fun with big brown eyes, Missy, a four-month-old husky, had a lot to tell her new owners. She wanted to say she'd like to follow them on hikes, go with them on ski trips, and sleep under the stars with them. Her previous owners said they had no time for her, but it only took one day in the shelter for new owners to swoop her up! **Adopted 9/24/15**

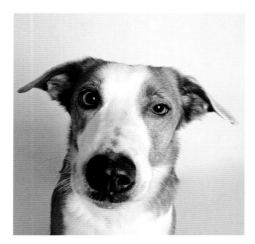
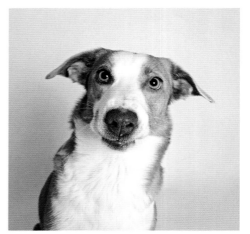
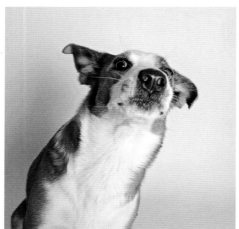
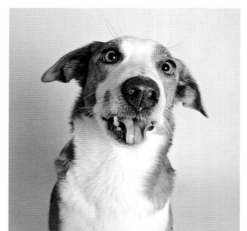

MIA

Mia, a four-year-old cattle dog mix, was surrendered when her former owner's landlord said she had to go. She was a straight-A student at dog university at the Humane Society of Utah, helping make her case to her new owners. In just two days, this darling found her forever home. **Adopted 10/14/15**

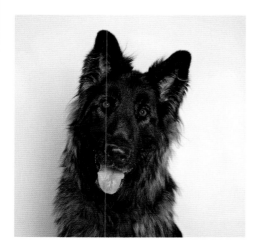
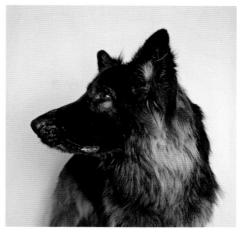
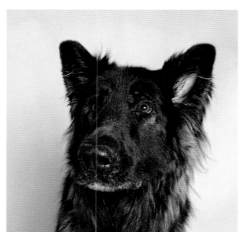
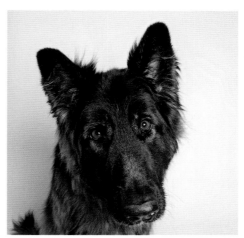

LEAH

Sadly, Leah, a loving eight-year-old German shepherd, came to the Humane Society of Utah grieving the loss of her owner. She was eager for comfort and needed bundles of hugs and reassurance, which the staff and volunteers gladly gave her. Luckily, Leah found another family to watch over and love. **Adopted 9/18/15**

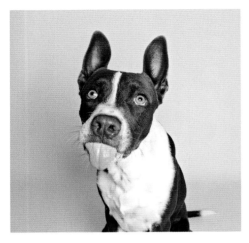
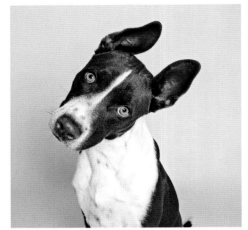
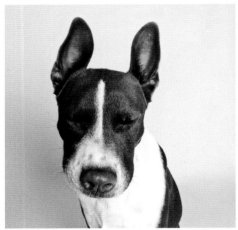
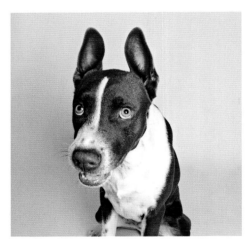

NERDS

Those eyes! That face! How could one not be seduced by this one-of-a-kind border collie and pit bull combination? Nerds was just eight months old at the time of his transfer from another shelter, but he already knew all his commands and was all about people pleasing. No wonder this unique pup landed with his forever family in one weekend. **Adopted 9/12/15**

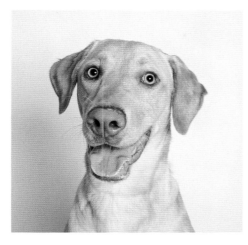
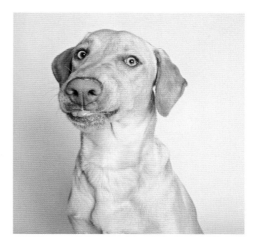
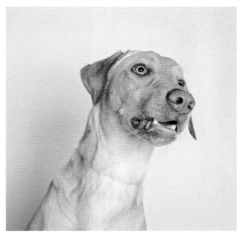
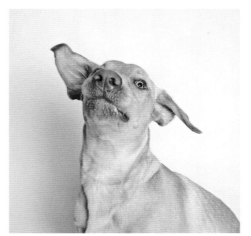

ROCKO

Rocko, a nine-month-old Lab, found himself at the shelter when his former family no longer had the time to care for him. Like any puppy, Rocko was beaming with excited energy and looking for someone who could keep up. He was already house-trained and got along great with kids, cats, and other dogs. Rocko found his perfect family in just a few days. **Adopted 9/23/15**

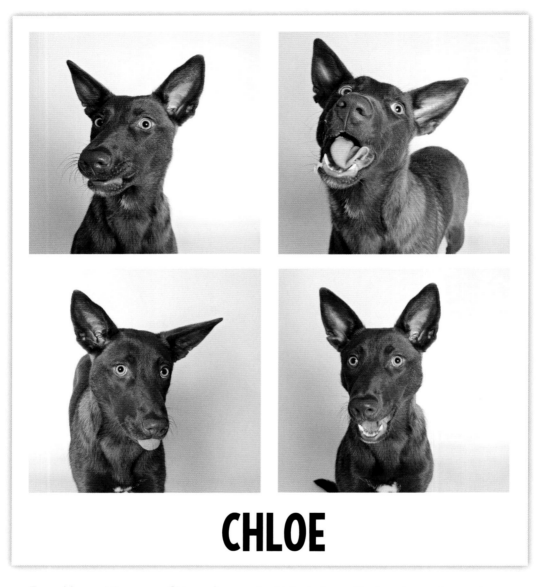

CHLOE

Tons of fun and then some, Chloe, a five-month-old Australian cattle dog mix, was too much for her previous owners to handle. Like any young puppy, Chloe needed ample exercise and positive guidance to flourish. Her irresistible personality helped her attract the right family!
Adopted 10/19/15

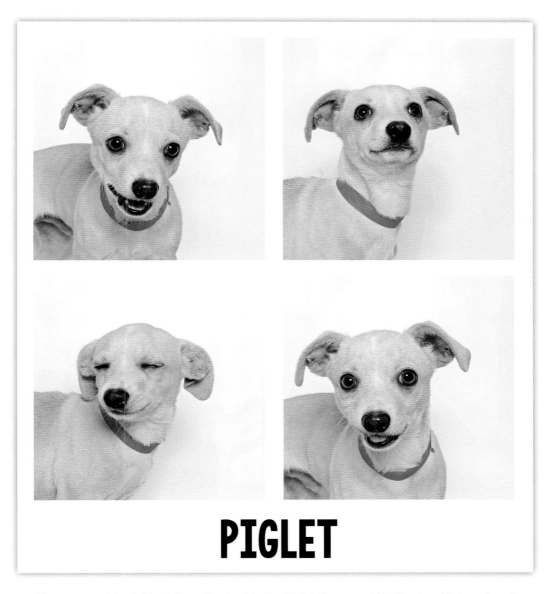

PIGLET

Like everyone's best friend, it was hard not to like Piglet, the year-old Chihuahua. He transferred in from an overcrowded California shelter to find his second chance at life. He got it! This friendly little man was adopted after his short stay at the Humane Society of Utah. **Adopted 9/17/15**

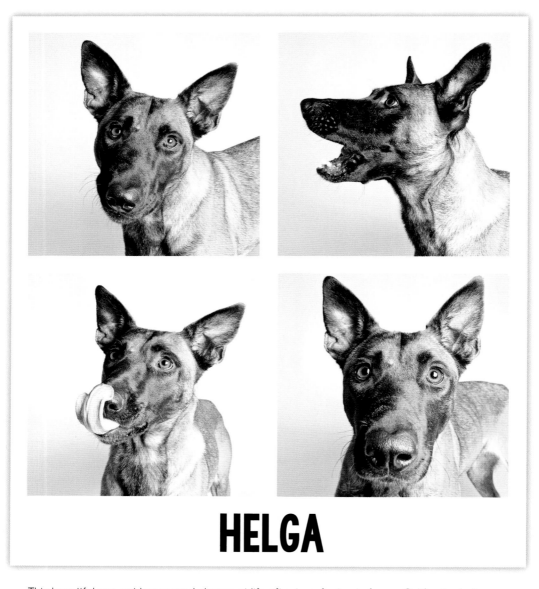

HELGA

This beautiful pup got her second chance at life after transferring in from a California shelter. Helga, a year-old Belgian Malinois mix, was a real people pleaser. She closely followed her favorite staff members like a shadow, patiently waiting for their next moves. She found her forever family in less than a week. **Adopted 8/08/15**

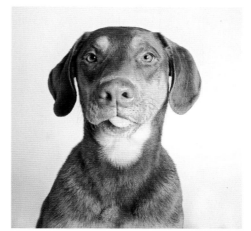
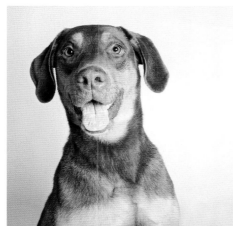
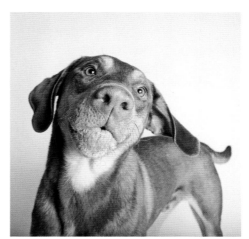

FLOYD

Floyd, a two-year-old Doberman mix, was surrendered because of his high-flying, energetic antics. He loved being the center of attention and making people laugh. Floyd was dubbed the shelter comedian, and his new owners were encouraged to exercise him often and provide lots of toys for his nonstop train of thought. They promised all that and more. **Adopted 8/22/15**

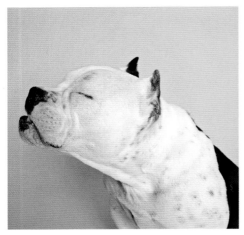
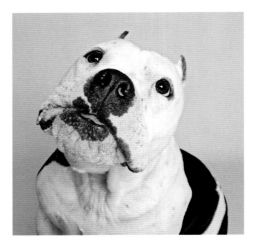
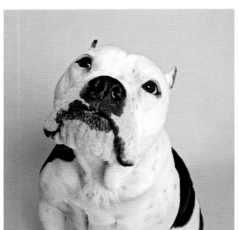
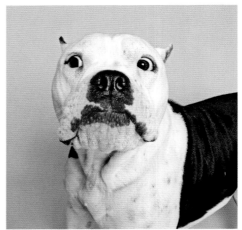

HUMPHREY

Transferring in from an overcrowded California shelter, this ten-month-old bulldog mix was a star in the making. Like any movie hunk, he won over everyone in his presence. A shelter staff member took one look at Humphrey and couldn't resist—she adopted him the next day!
Adopted 2/13/15

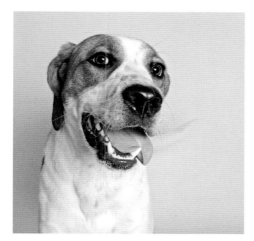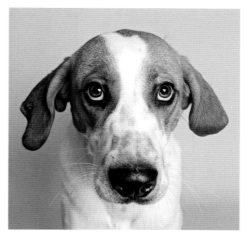

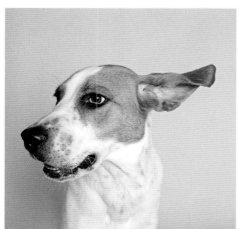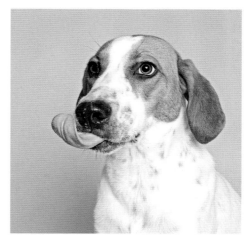

MOKI

Fish gotta swim, birds gotta fly, and Moki, a year-old treeing walker coonhound, had to follow his nose. He was trying his luck at the Humane Society of Utah after failing to find any in a California shelter. Fun loving and goofy, this young boy loved to serenade anyone who would listen. He was looking for someone who couldn't resist his hound dog charm, and he found them. **Adopted 9/13/15**

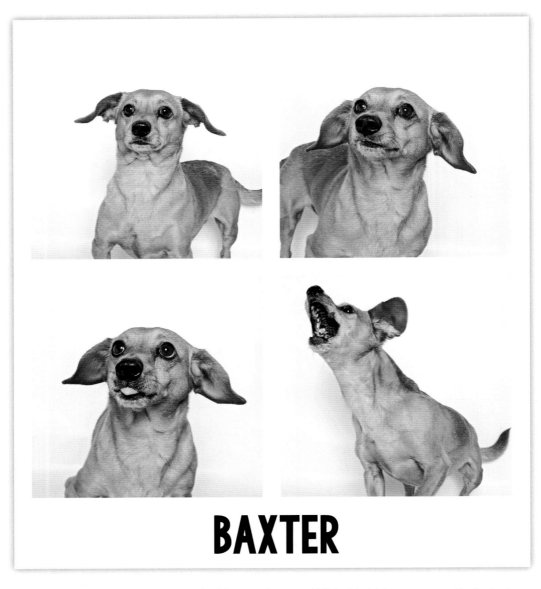

BAXTER

Family allergies landed Baxter at the Humane Society of Utah. At eight years young, Baxter had a firecracker of a personality. Nothing was going to slow this little man down. He enjoyed the company of other dogs and adults, and Baxter found his perfect match. **Adopted 10/21/15**

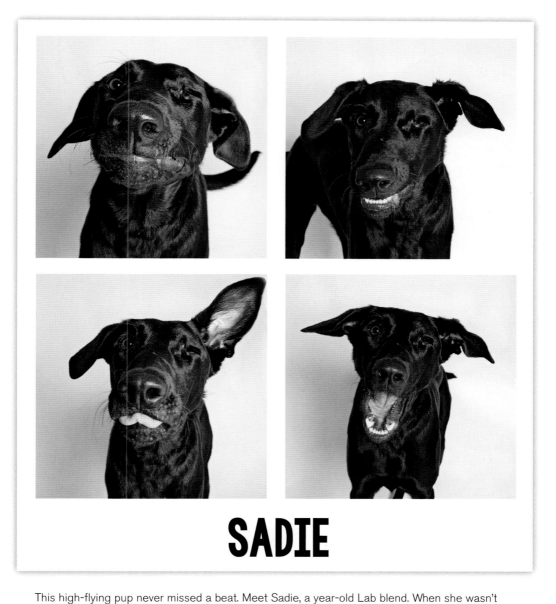

SADIE

This high-flying pup never missed a beat. Meet Sadie, a year-old Lab blend. When she wasn't catching treats, she loved romping around with everyone she met. Sadie is house-trained, gets along well with other dogs, and absolutely adores children. **Adopted 11/21/15**

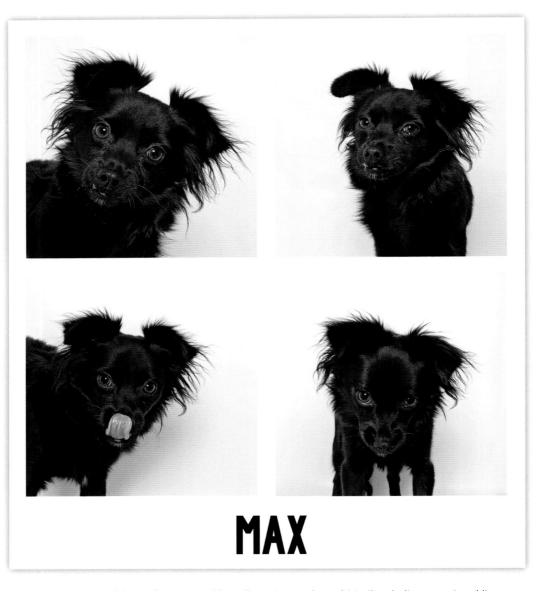

MAX

Small but mighty, Max, a three-year-old papillon mix, was brought to the shelter as a stray. His history was unknown, but the staff learned Max enjoyed the company of other dogs. Bold but reserved, Max was looking for a mature family that would respect his stoic personality. He found his perfect match. **Adopted 9/26/15**

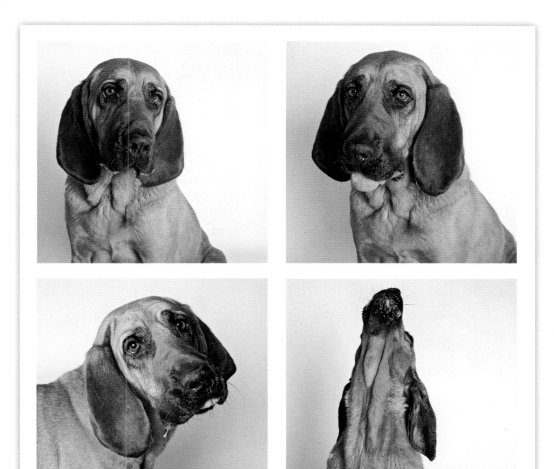

ROSE

It is pretty impossible not to adore this lovely lady! Rose came to the Humane Society of Utah from another shelter for her second chance. At just five years old, this bloodhound quickly won over the staff and volunteers with her pleasant demeanor and velvety soft ears. She already knew her basic commands, walked well on a leash, and could howl a tune. This heavenly hound found her match in less than a week! **Adopted 9/09/15**

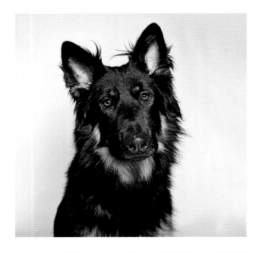
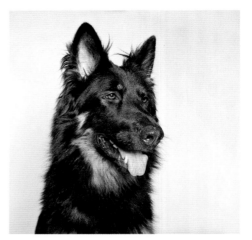
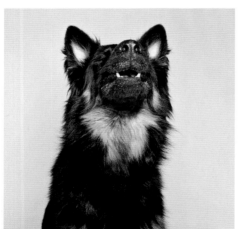
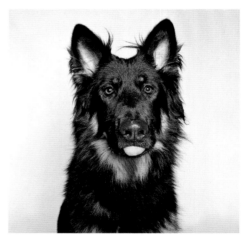

RORY

Move over, Don Draper: you have nothing on this handsome gent! Rory came to the Humane Society of Utah when he didn't get along with the cats in his former home. At just a year and a half old, Rory was sophisticated, well mannered, and could charm the pants off anyone he met. He found his forever home in just one day. **Adopted 7/23/15**

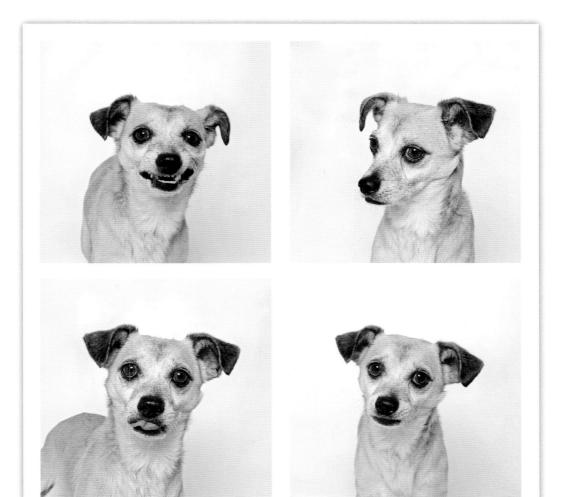

SHERMAN

Easily mistaken for an adorable meerkat, Sherman, a four-year-old Jack Russell–Chihuahua mix, left a shelter in California to call the Humane Society of Utah his temporary home. Small but mighty, Sherman could keep up with the most athletic of track stars! Running, jumping, and gobbling up treats were categories Sherman excelled in. He found his forever home with a family that valued his talents! **Adopted 10/03/15**

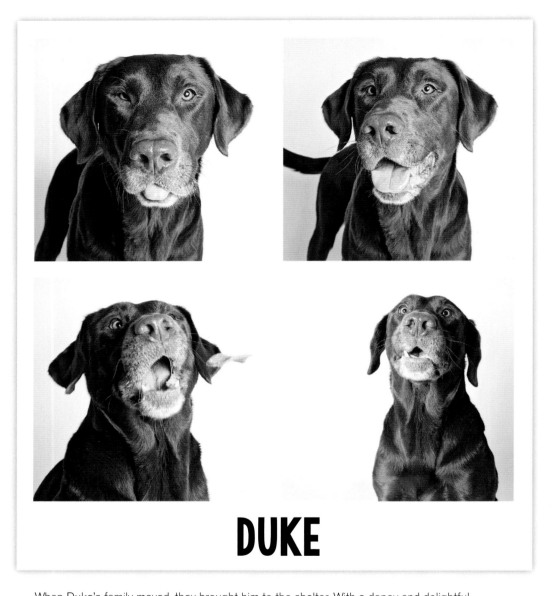

DUKE

When Duke's family moved, they brought him to the shelter. With a dopey and delightful personality that was hard to resist, Duke quickly became a volunteer favorite. This five-year-old chocolate Lab was already house-trained and was good with kids and other dogs. All that was missing was a family of his own. He got one! **Adopted 8/07/15**

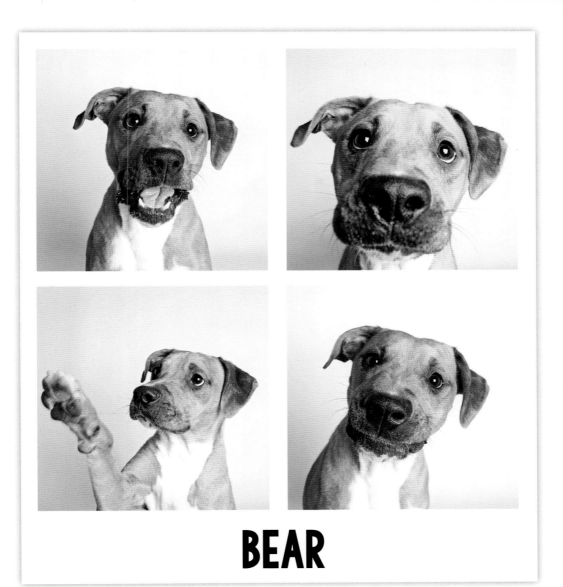

BEAR

Bear, a two-year-old boxer mix, transferred in from another shelter, so his history was a mystery. The big, beefy boy was the perfect match for a fun and active companion. Always looking to please, Bear knew a few commands and got along well with people and dogs alike. Bear caught the attention of his new owners and was adopted! **Adopted 8/19/15**

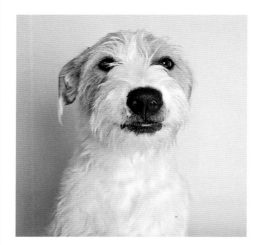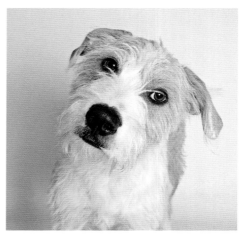
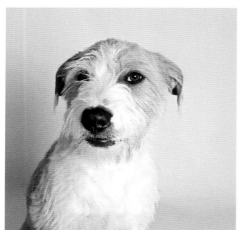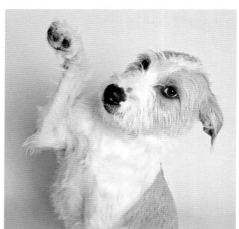

CHLOE

When Chloe's family did not have time for her, they brought her to the shelter. No home, no problem: nothing was going to discourage this year-old Airedale terrier mix. Chloe was all about fun and being the life of the party. She knew her basic commands, was already house-trained, and was just a joy to be around. Someone else agreed, and they took this bundle of joy home.
Adopted 1/01/15

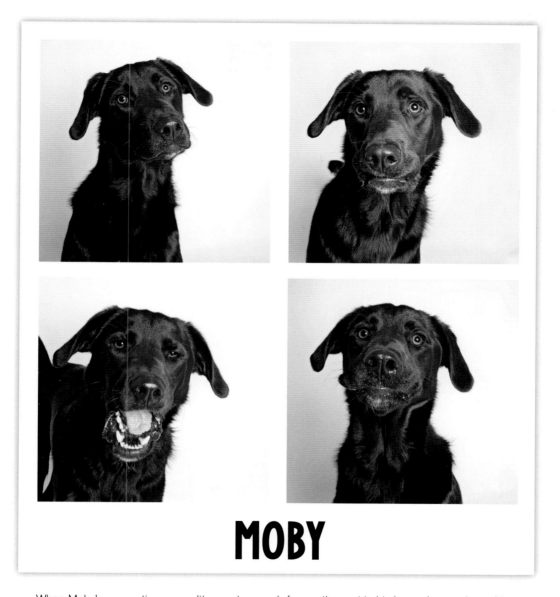

MOBY

When Moby's energetic personality was too much for another pet in his home, he was brought to the shelter. At just a year old, Moby, a Lab mix, was ready to zoom and play all day long. He was fortunate enough to find an active family to join on daily adventures. **Adopted 9/13/15**

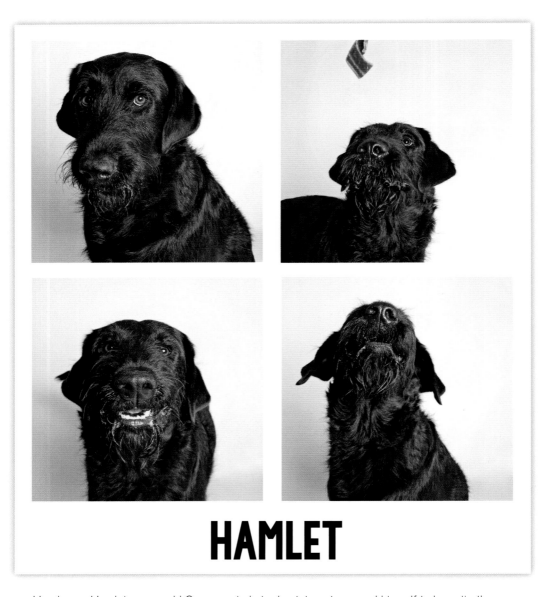

HAMLET

Handsome Hamlet, a year-old German wirehaired pointer mix, proved himself to be quite the ham during his stay at the shelter. He came from a smaller shelter in California and was quick to pick up on a command or two for a treat. He continues to perfect his treat-collecting skills in his new home. **Adopted 10/10/2015**

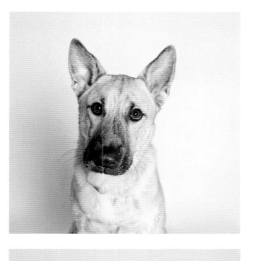
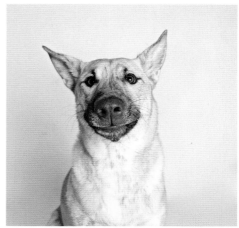
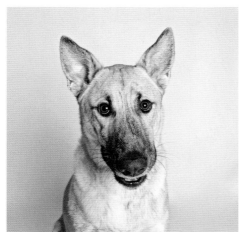
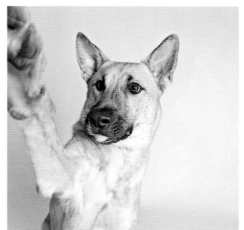

MAX

Max found himself at the shelter when his owners no longer had the time to care for him. At ten months old, Max was really just an oversized puppy. With a zest for life and an eagerness to please, Max was already house-trained and got along great with other dogs and kids. It didn't take long for someone to fall head over heels for Max. **Adopted 8/29/15**

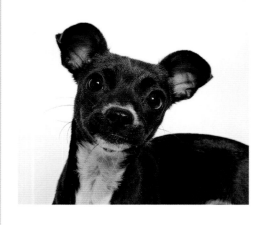
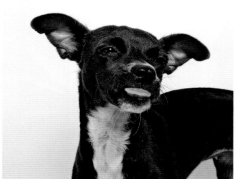
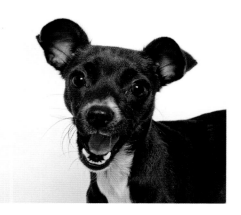
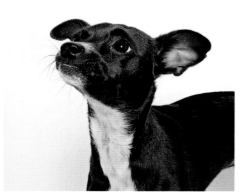

PENELOPE

When Los Angeles didn't work out for this starlet, she came to the Humane Society of Utah for another shot at life. At just two years old, this precious pup was in her prime. She adored other dogs and loved everyone she met. With a personality that could light up the stage, it's no wonder she found a home of her own. **Adopted 10/09/15**

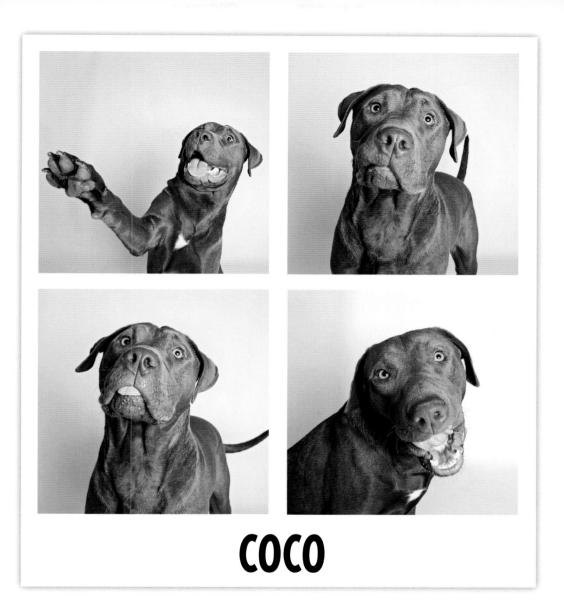

COCO

Coco, a pit bull blend, was dreaming of fields filled with daisies and green grass to roll in when he arrived at the shelter. He was too hyper for his last family and was looking to start fresh. At only ten months old, this big boy already knew a few commands and was ready to learn more. He joined a family that was eager to teach him. **Adopted 10/15/15**

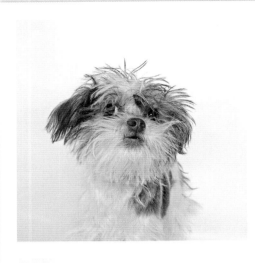
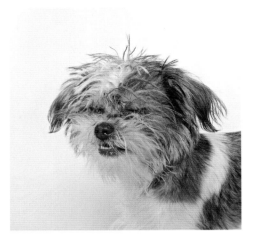
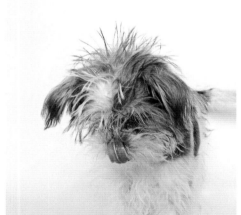
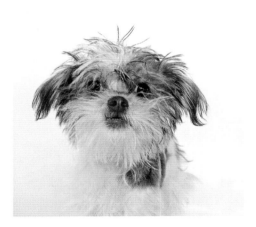

COOKIE

Bite-size Cookie loved to nibble, as most puppies do when they are learning where they can and can't put their mouths. The shih tzu–Chihuahua mix, only five months old at the time of her surrender, was placed in a loving foster home to learn the ropes. She absolutely adored other dogs but needed a mature home that could shower her with toys and lots of love. After a couple months, she found the perfect fit! **Adopted 11/15/15**

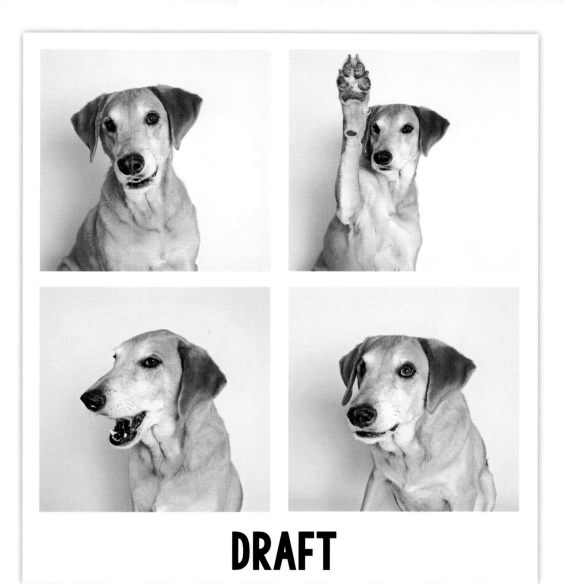

DRAFT

Draft was quite the character. He loved to interact with the shelter staff and other dogs. Sadly, he did not get along with feline friends in his previous home, and that is what landed him in the shelter. This jokester was all about keeping the party going. The six-year-old Lab mix found his second chance when he was adopted out to a kitty-free home. **Adopted 9/20/15**

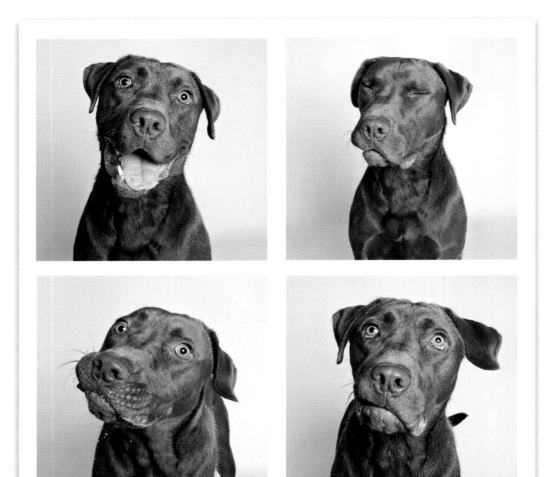

BOOMER

Boomer's handsome face was very easy on the eyes. This year-old Lab blend had looks that would stop people in their tracks. Boomer came from another shelter to try his luck at finding a forever home. His infectious smile could brighten anyone's day, and his cuddling skills weren't too bad, either. He got just what he was looking for: a forever family. **Adopted 8/08/15**

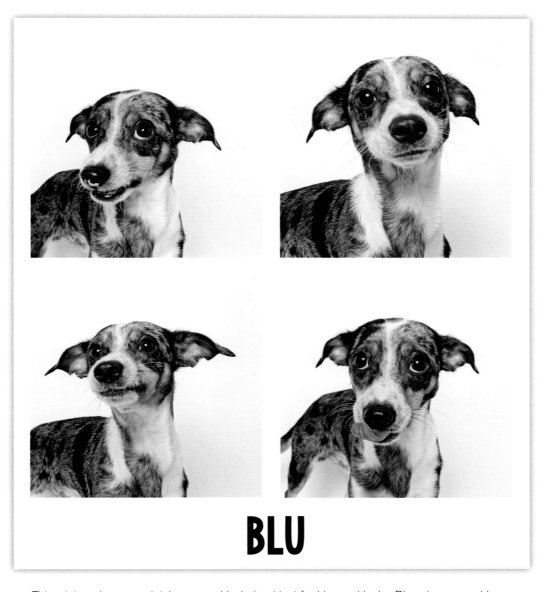

BLU

This mini-merle was certainly memorable, but not just for his good looks. Blu, a two-year-old Chihuahua blend, transferred in from a Los Angeles shelter for another chance at life. Likable in every way, Blu loved everyone he met and enjoyed being toted around underarm. He got just what he was looking for: a loving home of his own. **Adopted 8/29/15**

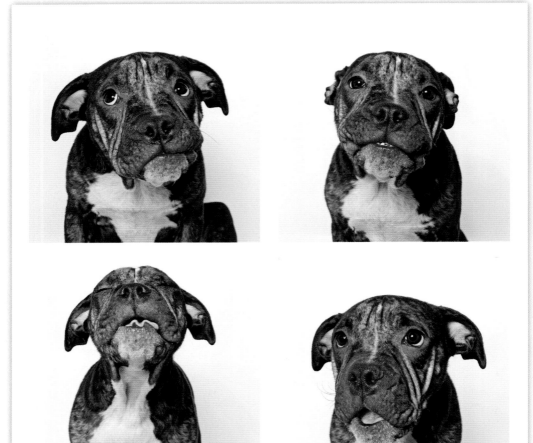

WILLOW

Willow was transferred from a California shelter to the Humane Society of Utah with her littermate. It was soon discovered that they both had demodectic mange and would require a lengthy treatment regimen in a loving foster home. This strong-willed, three-month-old hippo . . . err . . . English bulldog mix was determined to get better. In the process, she buttered up everyone she met with her adorable old-man face. She is still being treated for her condition and is learning to be the best pup she can be in her foster home. **Waiting**

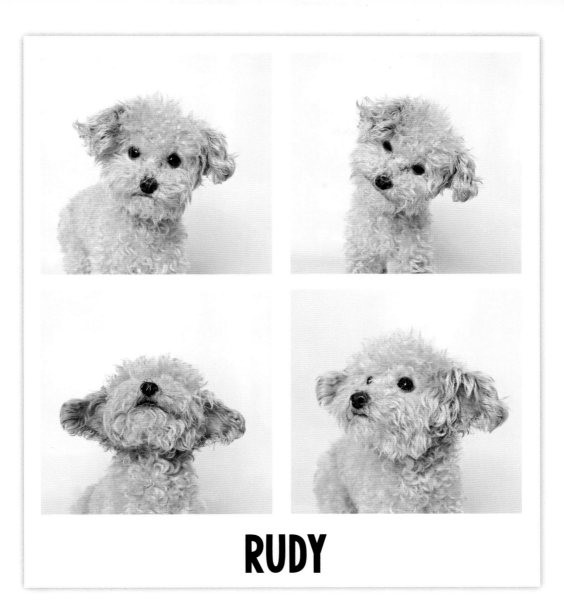

RUDY

Found as a stray, Rudy was in pretty rough shape. Weighing in at just under three pounds, this emaciated pup had a broken leg and was covered in matted fur. Too thin to operate on, Rudy was placed in a caring foster home to gain weight. The year-old miniature poodle mix quickly won over his foster family with his irresistible charm. After two months in his foster home, his foster family decided to make it official! **Adopted 5/15/15**

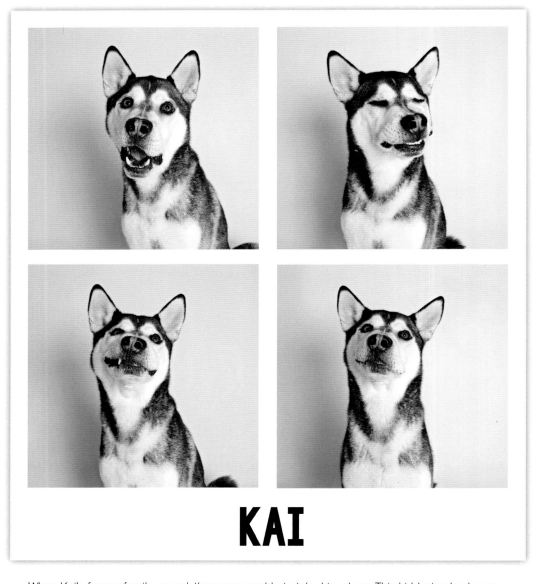

KAI

When Kai's former family moved, they were unable to take him along. This kid-loving husky was a knockout! At three years old, Kai was active yet well mannered. He was already house-trained, good with other dogs, and walked well on a leash. He was looking for that perfect active family to join on daily adventures, and he found them. **Adopted 8/28/15**

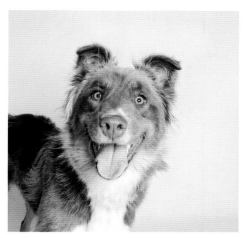
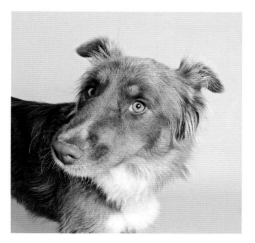
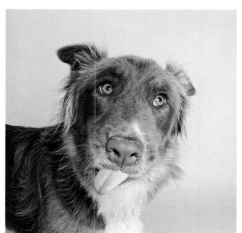
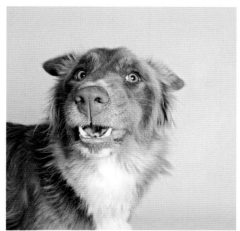

COOKIE

Cookie, a one-and-a-half-year-old border collie–Aussie mix, was described as a bit of a naughty girl by her previous owners. She used her smarts to her advantage, but just needed a little more guidance, patience, and a kind hand. Cookie would do anything for a tennis ball, and her new family was encouraged to use praise and reward her strengths to help her be the best Cookie she could be. Now Cookie has a bright future. **Adopted 8/28/15**

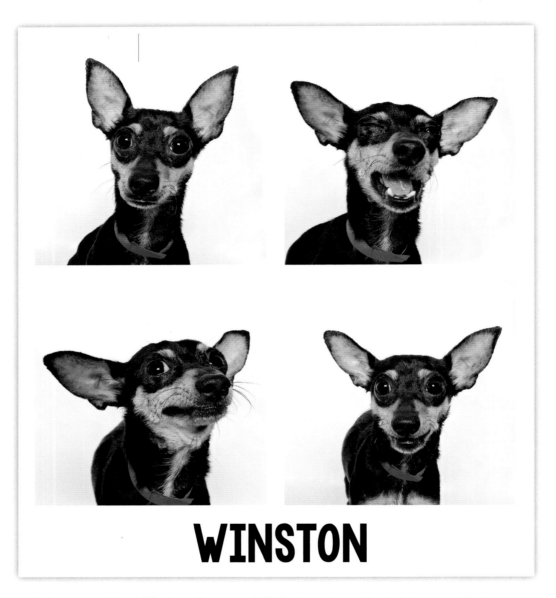

WINSTON

A funny guy at heart, Winston, a two-year-old Chihuahua mix, could entertain a crowd for hours on end. After failing to be adopted from a Los Angeles shelter, Winston gave the Humane Society of Utah a try. Things worked out well for this lucky pup. **Adopted 8/09/15**

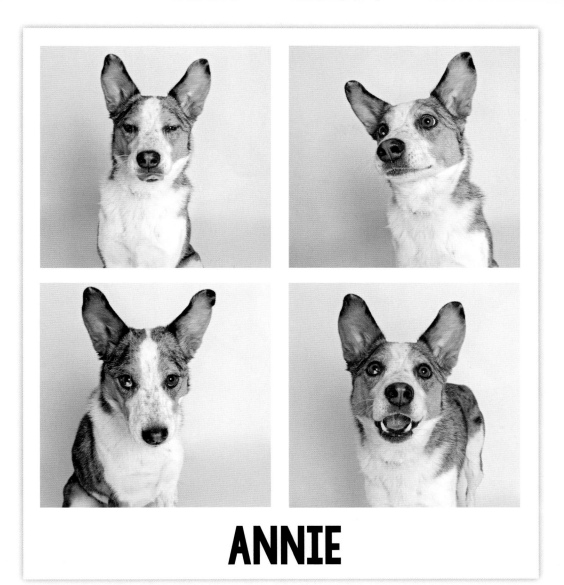

ANNIE

When Annie's former owner lost his home, he brought her to the Humane Society of Utah to find another. Smart as a whip, Annie, a five-year-old Australian cattle dog, didn't waste any time showing off her award-worthy personality. This staff favorite quickly found a family that promised to take her on all their mountain adventures! **Adopted 9/05/15**

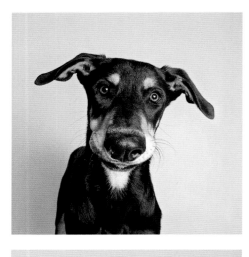
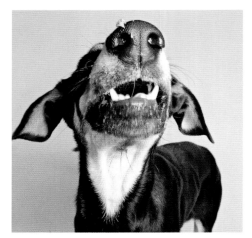
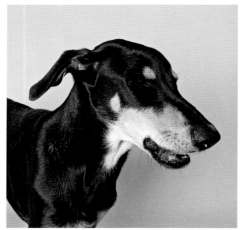
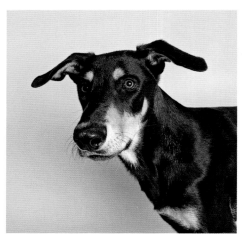

OTTER

Otter, a ten-month-old Doberman mix, resembled his namesake. He was playful, goofy, and loved making shelter staff laugh by trying to sneak all the treats. Who could resist this face? Not many it turns out; Otter was adopted shortly after his transfer from a California shelter.
Adopted 9/12/15

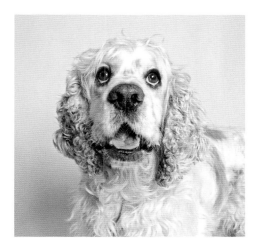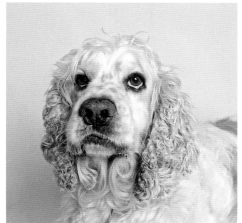
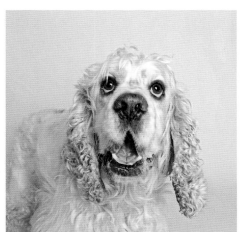

MILO

When another pet in the family didn't get along with him, Milo found himself at the shelter. At seven years old, Milo was well out of his puppy stage but still spry. Milo enjoyed walks with volunteers and showing off his basic commands for treats. With all these great traits, it's no wonder he found his dream home. **Adopted 10/10/15**

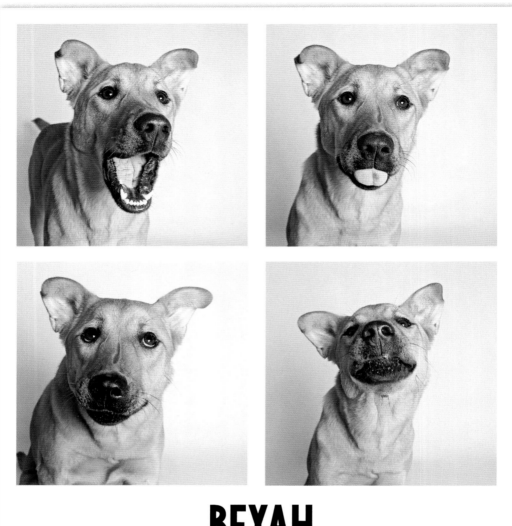

BEYAH

With no home to call her own, Beyah found herself at the Humane Society of Utah looking for one. At just nine months old, this German shepherd mix was all about the fun. Beyah loved to romp and play and was looking for an active family that could keep up and teach her the ropes. She found one! **Adopted 9/30/15**

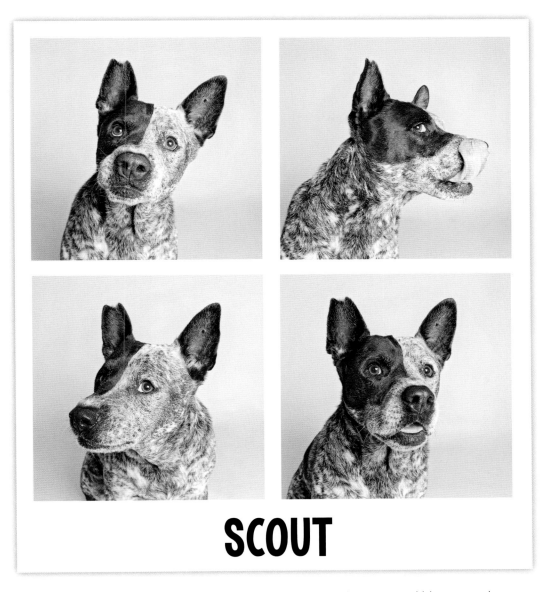

SCOUT

Scout was brought to the Humane Society of Utah as a stray. At two years old, he was ready to listen and follow your every move, in true Australian cattle dog form. While he got along with other dogs, his focus was all on people. He found someone who admired his ready-to-get-it-done drive and handsome looks. **Adopted 10/18/15**

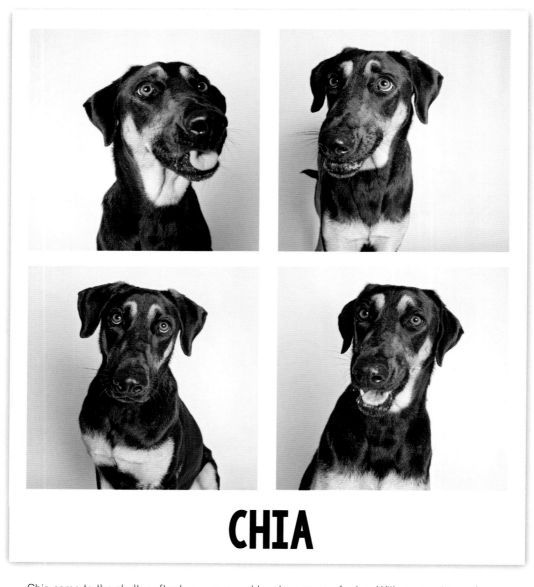

CHIA

Chia came to the shelter after her owner could no longer care for her. With expressive eyebrows that complemented her ladylike demeanor, the statuesque beauty quickly became a staff and volunteer favorite during her shelter stay. This brown-eyed beauty soon caught the attention of an adopter and found a new home. **Adopted 9/22/15**

LOOK AT US NOW!

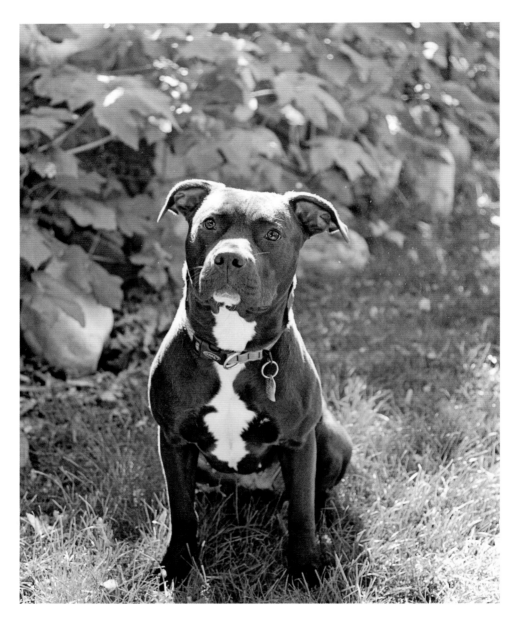

ATHENA
(PAGE 20)

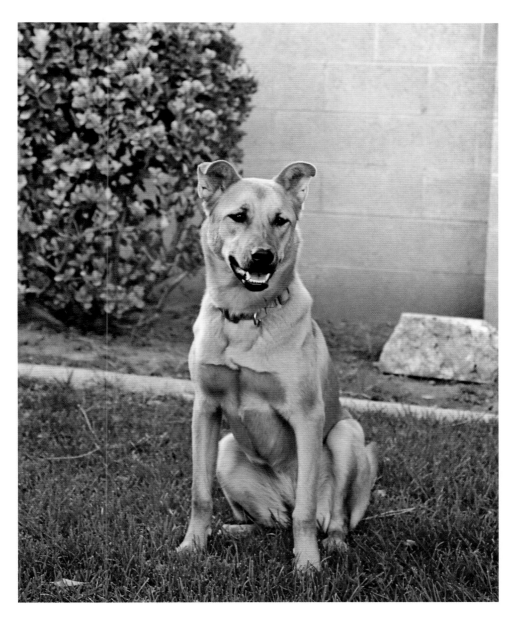

BEYAH
(PAGE 106)

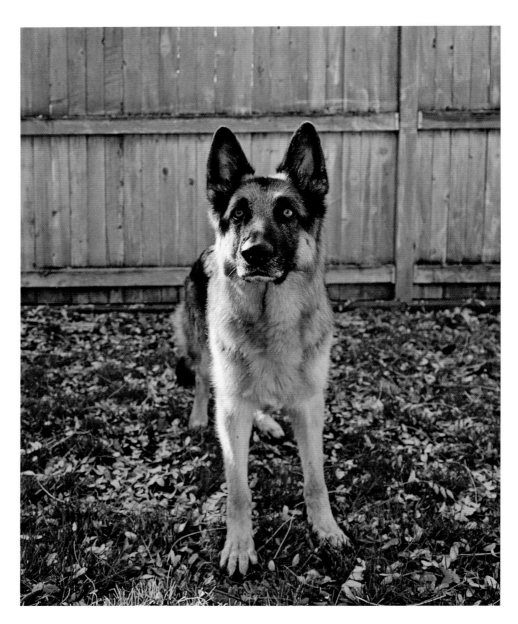

BRUNO
(PAGE 41)

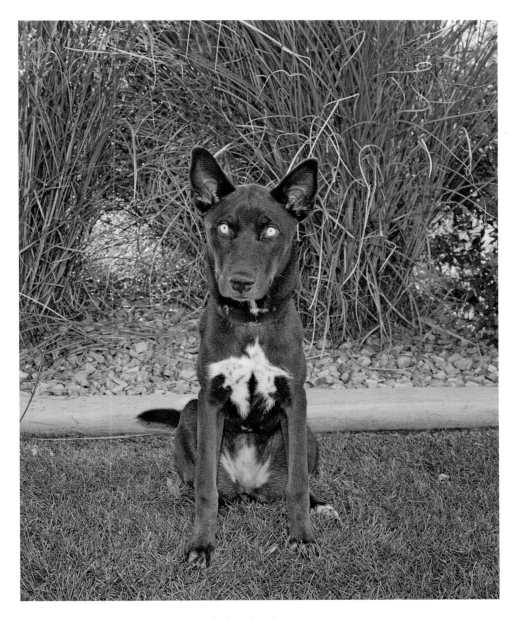

CALYPSO
(PAGE 13)

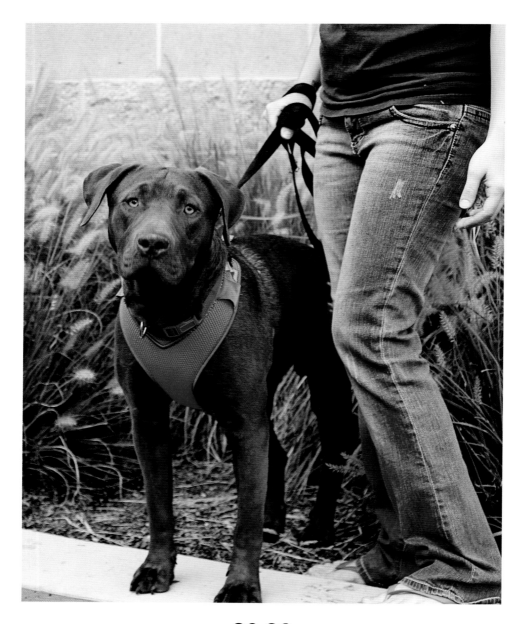

COCO
(PAGE 93)

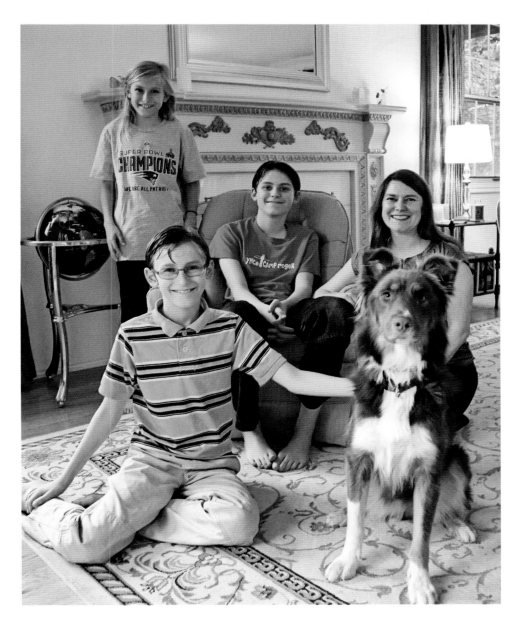

COOKIE

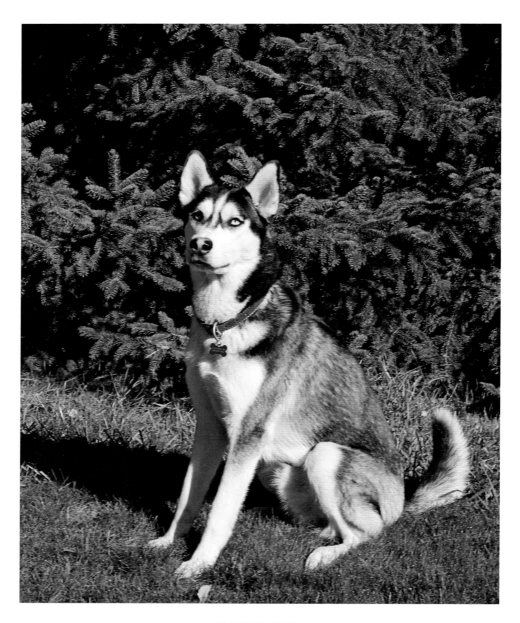

DIESEL
(PAGE 16)

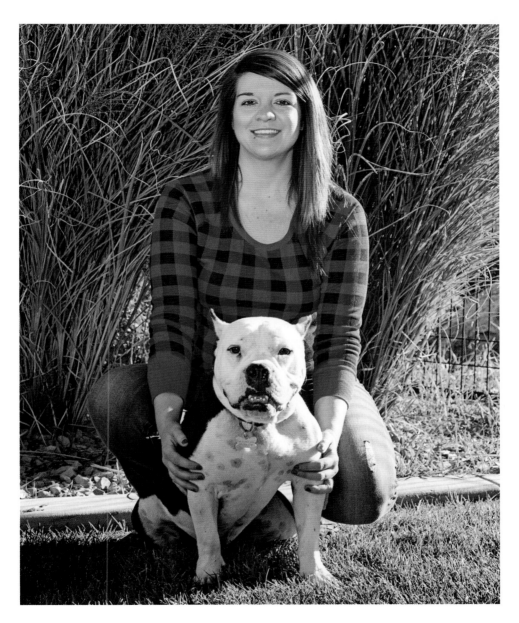

HUMPHREY
(PAGE 78)

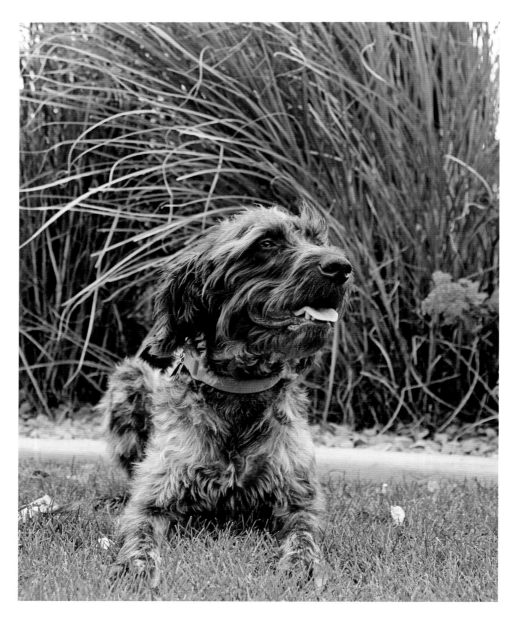

KODA
(PAGE 5)

MILO
(PAGE 105)

NITA
(PAGE 64)

OSCAR
(PAGE 40)

RUDY

RUDY
(PAGE 99)

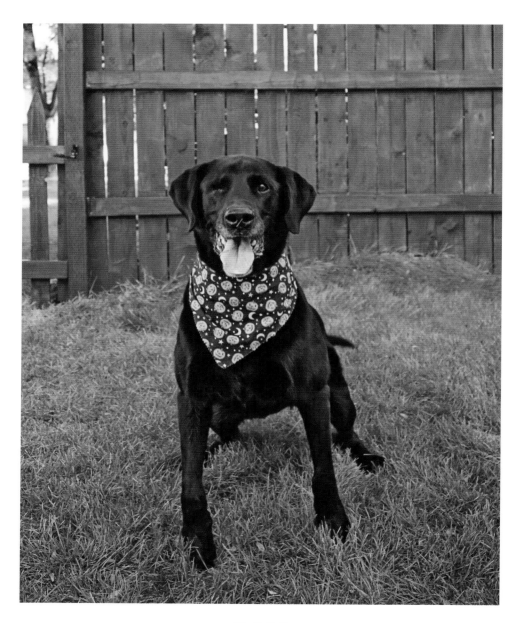

SAM
(PAGE 17)

SULLY
(PAGE 18)

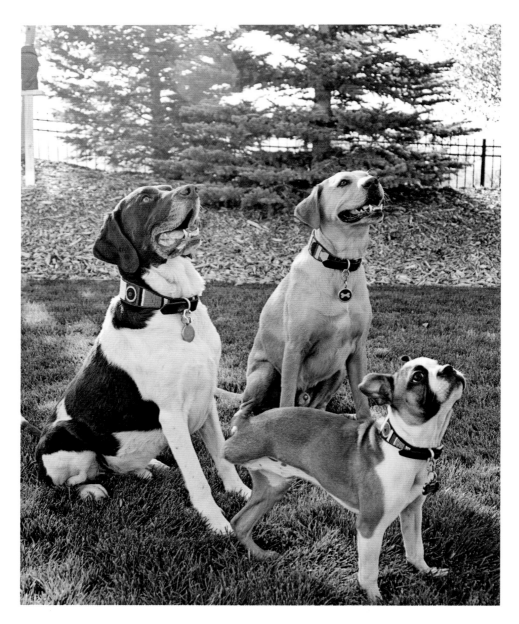

WALLACE
(PAGE 30)

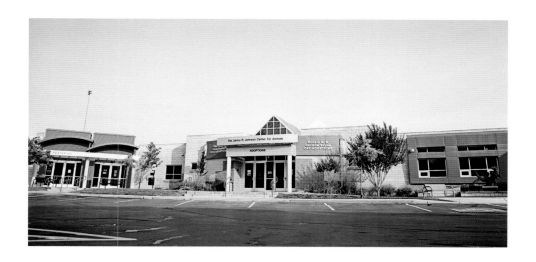

ABOUT THE SHELTER

All of the dogs photographed in this book found themselves at the Humane Society of Utah. Founded in 1960, the Humane Society of Utah's (HSU) original mission was, and still remains, to eliminate pain, fear, and suffering in all animals. Since that time, the HSU has always fostered an atmosphere of love, compassion, and respect for Utah's animals, and worked hard to ensure that all pets have a chance to be placed into a loving home.

HSU is an open-admissions shelter, meaning that its doors are always open for homeless and helpless pets in need. Furthermore, there is no set limit on the length of time that pets may remain in the HSU's adoption program.

Beginning in 2014, an expansion and renovation project was completed that allowed the HSU to save record-setting numbers of homeless pets. Through an education-focused adoption process, positive image promotion of shelter pets, and many other programs and services, the Humane Society of Utah looks forward to saving even more lives in the years to come.

Andrews McMeel Publishing
a division of Andrews McMeel Universal
1130 Walnut Street, Kansas City, Missouri 64106

www.andrewsmcmeel.com

16 17 18 19 20 SDB 10 9 8 7 6 5 4 3 2 1

ISBN: 978-1-4494-7784-4

Library of Congress Control Number: 2015955849

Editor: Dorothy O'Brien
Designer/Art Director: Holly Ogden
Production Manager: Tamara Haus
Production Editor: Grace Bornhoft
Demand Planner: Sue Eikos

ATTENTION: SCHOOLS AND BUSINESSES
Andrews McMeel books are available at quantity discounts with bulk purchase
for educational, business, or sales promotional use. For information,
please e-mail the Andrews McMeel Publishing Special Sales Department:
specialsales@amuniversal.com.